DIGITAL
hand lettering
AND
MODERN
Calligraphy

DIGITAL
hand lettering
AND
MODERN
Calligraphy

Essential Techniques Plus Step-by-Step Tutorials
for Scanning, Editing, and Creating on a Tablet

Shelly Kim

QUARRY

Brimming with creative inspiration, how-to projects, and useful information to enrich your everyday life, Quarto Knows is a favorite destination for those pursuing their interests and passions. Visit our site and dig deeper with our books into your area of interest: Quarto Creates, Quarto Cooks, Quarto Homes, Quarto Lives, Quarto Drives, Quarto Explores, Quarto Gifts, or Quarto Kids.

First Published in 2019 by Quarry Books, an imprint of The Quarto Group, 100 Cummings Center, Suite 265-D, Beverly, MA 01915, USA. T (978) 282-9590 F (978) 283-2742 QuartoKnows.com

Quarry Books titles are also available at discount for retail, wholesale, promotional, and bulk purchase. For details, contact the Special Sales Manager by email at specialsales@quarto.com or by mail at The Quarto Group Attn: Special Sales Manager, 100 Cummings Center, Suite 265-D, Beverly, MA 01915, USA.

10 9 8 7 6 5 4 3 2 1

ISBN: 978-1-63159-720-6

Digital edition published in 2019
eISBN: 978-1-63159-721-3

Library of Congress Cataloging-in-Publication Data
Names: Kim, Shelly, author.
Title: Digital hand lettering and modern calligraphy : essential techniques
 plus step-by-step tutorials for scanning, editing, and creating on a
 tablet / Shelly Kim.
Description: Beverly, MA, USA : Quarto Publishing Group USA, Inc., 2019. |
 Includes bibliographical references and index.
Identifiers: LCCN 2019019032 (print) | LCCN 2019021367 (ebook) | ISBN
 9781631597213 (ebook) | ISBN 9781631597206 (pbk.) | ISBN 9781631597213 (eISBN)
Subjects: LCSH: Lettering--Technique. | Calligraphy--Technique. |
 Lettering--Data processing. | Calligraphy--Data processing. | Computer art.
Classification: LCC NK3600 (ebook) | LCC NK3600 .K55 2019 (print) | DDC
 745.6/1--dc23
LC record available at https://lccn.loc.gov/2019019032

Interior Design & Page Layout: Samantha J. Bednarek

Printed in China

dedication

To Richard, who always believes in everything I do—no matter how crazy the idea. You are my #1 supporter, motivator, and fan.

To all the creatives and amazing people out there who need an extra push: Go and pursue your dreams. You totally got this!

contents

8 Preface: Our Lettering Journey!

1 LETTERING ESSENTIALS

2 DIGITIZING YOUR LETTERING

3 LETTERING ON A TABLET

4 DIGITAL LETTERING PROJECTS

12 Getting Started with Brush Lettering

13 Modern Calligraphy Tools

16 Modern Calligraphy Basics

19 The Drills

21 Reviewing Drills & Lettering Guidelines

24 Connecting Letters

26 Exploring Other Styles

36 Designing Quotes

40 Overview

41 Capturing Your Lettering

44 Creating a Digital Lettering File

50 Essential Tools

51 Getting Started in Procreate

53 Learning the Basics

69 Essential Procreate Techniques

97 Combining Procreate & Adobe Sketch

104 Colorful Geometrics & Lettering

107 Custom Invitations

110 Creating Cards with Adobe Sketch & Procreate

112 Colorful Name Tags

116 Love Tags

120 Creating Vinyl Lettering with Silhouette Cameo

126 Applying Vinyl to Acrylic Paint

128 Foil Lettering with a Laminator

132 Inspiration Gallery

139 Practice Sheets

141 Resources

141 About the Author

142 Acknowledgments

143 Index

Preface: Our Lettering Journey!

I am so, so excited for you to join me on this fun lettering journey! I remember when I first wanted to learn. I was so overwhelmed and intimidated by all the brands, materials, and just getting started with the process of lettering. I totally understand the challenges and struggles you might be facing or have already faced. I am here for you and excited to share everything I know about getting started with the lettering process, from using brush pens and digitizing to lettering on the iPad Pro. This book contains a lot of information, but let's take a deep breath and do this together, step by step, and, most important, take the time to reflect and enjoy the learning process.

Here's a quick backstory on how I came across the beautiful art of modern calligraphy. When I was working full-time, I was so involved with work that I forgot to appreciate the little things in life. I saw myself always stressed-out and dedicating all my time and energy to work. Basically, all I knew in life was to work, and I realized how unhealthy my life-work balance was. One day, I was scrolling on social media and searched "positive quotes, positive affirmations, positive vibes," and that's how I came across the beautiful art of typography and hand lettering. This is when I discovered modern calligraphy using brush pens. My life changed in that moment because my new purpose in life was to hand letter positive messages to friends, family, and myself. Shortly after I discovered this beautiful art, I absolutely loved the journey and wanted to create on a daily basis. My life has been so much happier since discovering this beautiful art because my life has comprised of spreading positive vibes, creating daily, and sharing my positive messages on social media.

My message to you is modern brush lettering—similar to modern calligraphy (depending on the type of medium [pens]) used—is so beautiful and unique that anyone can totally achieve it! (Yes, you can too!) The amazing thing about lettering is how each letter has its own style and can be made different with the use of embellishments and flourishes.

My advice in getting started in this beautiful art of lettering is to focus on your lettering journey only! This art form can look intimidating, but let me assure you, it's not! I can only speak to my experience, but I mean it when I say that anyone can learn lettering! Remember that everyone starts somewhere, and your journey will be different from others because we all learn and process information differently. To give you some insight, it took me months to finally find my favorite brush pen and understand there was a technique to calligraphy because I really had no idea what I was doing in the beginning. But I am excited to have this opportunity to share with you everything I wish I knew about lettering when I first started this journey.

When you think about it, lettering, brush lettering, and modern calligraphy make up an art form. This is the reason why muscle memory plays a crucial role in lettering—your day one compared to day thirty into lettering will feel totally different. Keep in mind, with practice and patience anything is totally possible! During your journey, take joy in exploring and let lettering bring out your creative side.

Remember, I am always here for you, and I would love to be a part of your learning process. Feel free to reach out to me anytime via Instagram or email at lettersbyshells@gmail.com. I would love to be your support system throughout this lettering journey!

With love,

shelly

#letscreateletters

Year 1: January

Year 1: November

Year 2: January

Year 3: November

lettering essentials

Why begin with hand lettering? To create beautiful digital lettering, it's absolutely critical to know its fundamentals, whether you're using a brush pen on paper or a stylus on a tablet screen. And while there are important differences—for example, a stylus is far more responsive to pressure than a brush pen tip— working with a brush pen on paper will help you build the skills needed to understand the essential strokes and forms of hand lettering and modern calligraphy.

The main style of brush lettering presented in this book is modern calligraphy. We also explore several creative modifications to it, including bounce and flourishes, as well as some other lettering styles.

Getting Started with Brush Lettering

BEFORE WE BEGIN, I want to share something with you that I share with all my workshop students: When I picked up the brush pen for the first time, I had no idea where to start. Not only did modern calligraphy appear intimidating, but there were so many supplies out there. I also didn't understand that there was a technique to using brush pens. During the first couple of months, I literally applied one degree of pressure—heavy—to every brush pen I used and wondered why the result didn't look like modern calligraphy. Essentially, I didn't acknowledge that there was a specific way to achieve the desired strokes when using brush pens, completely ignoring the fundamentals of calligraphy. After months of frustration, I came to realize that the basics are the fundamentals of modern calligraphy. Without the understanding and knowledge of the basics and common drills, using brush pens to create modern calligraphy will be very challenging. Together, let's understand the basics, drills, and the tools to help you become more familiar with your brush pen.

There's definitely a learning curve when comparing a brush pen to an Apple Pencil for the iPad. When using brush pens, there are specific ways to hold the pen to achieve specific strokes and to ensure the brush tip does not get frayed or ruined. However, when using the Apple Pencil for the iPad, there's more flexibility when holding the pencil at different angles to achieve desired strokes.

Modern Calligraphy Tools

WHEN IT COMES DOWN TO THE TOOLS, the number of available useful brands of pens and paper these days can be quite overwhelming. I totally get it, because I was in that same position when I first started modern calligraphy— I bought every brand out there. Little did I know that it would be hard to understand how to use each brand of brush pen and paper, since they were all made with a different intent.

Finding the best brush pen and paper may be challenging if you're unsure where to start because the options are endless. During this search, you'll find that brush pens come in a range of tip sizes: large, medium, and small. When it comes to paper, some paper brands may be more textured, contain fibers, be heavier or lighter in weight, or be more transparent or opaque, among other properties.

As you begin your lettering journey, know that every brush pen has a different but unique purpose (see page 14). There might be a brush pen brand that you aren't in love with, which is totally okay. The most important part of the process is to find the perfect brush pen brand for your journey. Keep in mind that, typically, the larger the brush tip, the easier it is to achieve larger-sized lettering. On the other hand, the smaller the brush tip, the easier it is to achieve smaller-sized lettering.

Let's get started!

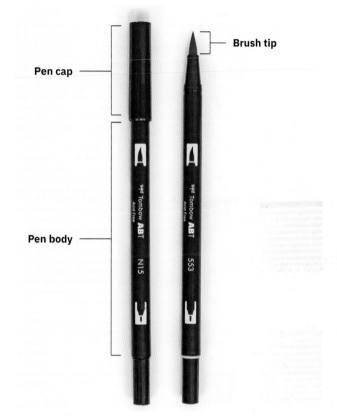

Pen cap

Brush tip

Pen body

Anatomy of a brush pen.

Brush Pens

There are many brush pen brands that I absolutely love for different reasons. For the purpose of this book, I only discuss the brands I recommend for beginners and the unique qualities of each.

FOR SMALL-SIZED LETTERING

- **Tombow Fudenosuke Brush Pen (Hard or Soft Tip).** The hard-tip pen typically is stiffer and firmer when lettering, requiring much heavier pressure when trying to achieve certain strokes. It will feel weird at first, but feel free to apply significantly more pressure when using this pen versus the soft tip. The soft-tip pen is a lot more flexible when lettering, requiring much less pressure for some strokes.
- **Pentel Fude Touch Sign Pen.** This brush pen has a small brush tip and is very flexible, making it easy to achieve smaller-sized lettering.
- **Marvy Uchida LePen Flex.** This brush pen has a slim pen body making it easier to grip and hold. Also, the brush tip is much smaller in size and very flexible, making it easier to apply pressure and control strokes.

FOR MEDIUM-TO LARGE-SIZED LETTERING

- **Tombow Dual Brush Pen.** The entire large brush tip flexes when you apply medium to heavy pressure.
- **Sakura Koi Coloring Brush Pen.** The tip of this brush pen will significantly bend when you apply heavy pressure.
- **Royal Talens Ecoline Brush Pen.** This brush pen has a flexible and inky brush tip, allowing the ink to flow more easily as you apply different pressures when lettering, almost creating an ombré effect.
- **Crayola Broad Line Marker.** This marker has a wide tip, and the body of the brush tip can be used when applying heavy pressure. Also, the tip of the marker can be good for a more consistent light pressure stroke.

Paper

When practicing your lettering, the goal is to practice on a paper type with a smooth finish to ensure that the brush pen lifespan is extended. If a paper brand contains fibers, you're essentially practicing your lettering on a textured/rough surface. The rough surface will then cause the brush pens to fray much earlier than expected, which will create a challenge when lettering. However, as long as the paper is smooth, the brush pens should glide smoothly during lettering. It's always a good idea to try a few different brands to find the best practice paper for you because depending on the amount of pressure (light, medium, or heavy pressure) applied and the brush pen you're using (small- or large-sized brush pens), you may notice a difference in paper types.

PAPER FOR LETTERING PRACTICE

- **HP Premium Choice LaserJet Printer Paper (32 lb [120 gsm]).** This paper is my go-to for lettering practice because the paper has a smooth finish, making it much easier to letter on.
- **Rhodia Paper.** I love how smooth this paper is, which allows the brush pens to easily glide when lettering.
- **Hahnemühle Hand Lettering Paper.** This brand is probably the smoothest paper I have ever tried for lettering, making it much easier for the brush pens to glide smoothly when applying any type of pressure.

PAPER FOR PROJECTS

These types of paper are thicker and heavier in weight, with a smooth finish, making them great for card-making, prints, name tags, banners, and so on.

- **Strathmore® 400 Series Mixed Media Paper**
- **Hammermill® Premium Color Copy Cover Paper (60 lb [162 gsm], 80 lb [216 gsm], or 100 lb [271 gsm])**

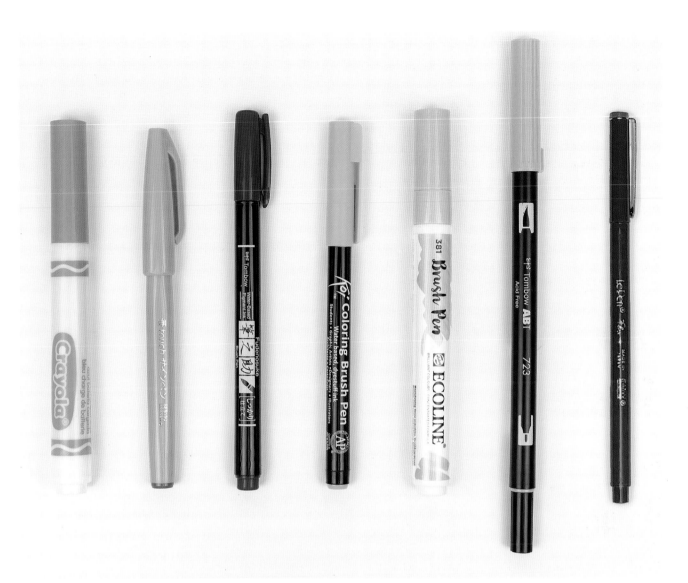

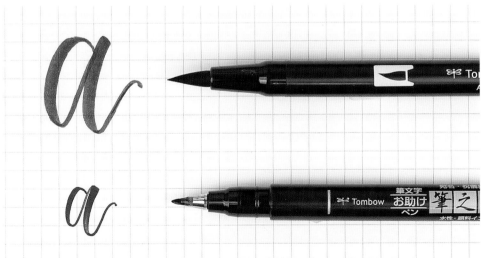

ABOVE: Brush pens. From left to right: Crayola, Pentel, Tombow Fudenosuke, Sakura Koi, Royal Talens Ecoline, Tombow Dual and Mary Uchida LePen Flex.

LEFT: Comparing the letter "a" using a large brush pen (Tombow Dual) and a small brush pen (Tombow Fudenosuke).

Modern Calligraphy Basics

Holding Your Brush Pen

In my experience, after teaching so many students, there's no right or wrong way to hold a brush pen. I truly want this experience to be stress-free, and, truthfully, we all hold our pens, markers, and pencils in different ways. However, with that in mind, I would still love to share a few recommendations that have helped me during my lettering journey. These recommendations and tips have saved me so much time while learning this art.

GRIPPING THE BRUSH PEN

I personally hold my brush pen the same way as if I am writing a letter and holding a pencil, marker, or pen. Take some time to explore your own grip and see what feels most comfortable for you.

HOLDING/POSITIONING THE BRUSH PEN

While at first uncomfortable, holding the brush pen at a 45-degree angle to the paper enables the entire body of the brush tip to be used when applying light pressure, medium pressure, and heavy pressure.

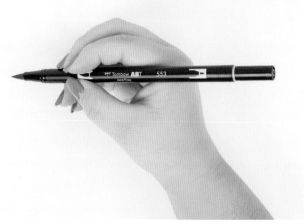

Gripping the pen.

tips
• Holding the brush pen at a horizontal angle, where the body of the pen is nearly parallel to your body while the tip makes contact with the paper will help you use the entire side of the brush tip for the strokes, specifically the downstrokes.

• Avoid holding the brush pen at a 90-degree angle to the paper when doing your downstrokes because all the pressure will be applied to the tip of the brush pen, ultimately ruining the brush tip.

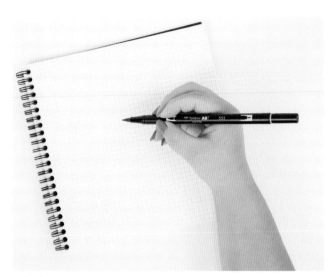

Gripping the pen and angling the paper.

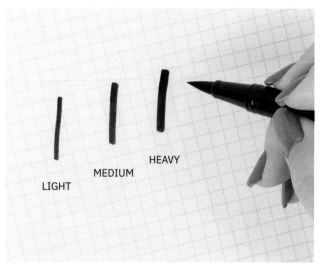

Pressure levels: light, medium, and heavy.

ANGLING THE PAPER

I usually angle the paper as if I'm about to write a letter. There really is no right or wrong way to do this. Find the best angle that works for you!

ADJUSTING PRESSURE LEVELS

Something to take note of when using brush pens is that your pressure can vary between light, medium, and heavy pressure. We explore this further on the following pages.

tip I encourage you to take a moment to explore holding and positioning the brush and paper to find a method that you prefer without feeling any discomfort. Just take a deep breath and have fun with it.

Thick Down and Thin Up

First and foremost, my advice to you is to always remember two things when practicing modern calligraphy (it will help make sense of everything): "Thick Down" and "Thin Up." Keeping these two fundamentals in your mind is important as you begin calligraphy. Let's take a deep breath and get started.

tip Because they're unfamiliar, you may find that upstrokes are more challenging than downstrokes. Keep in mind that these upstrokes don't have to be hairline thin.

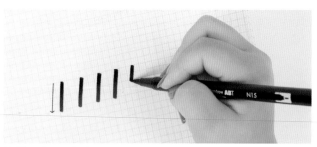

Making downstrokes.

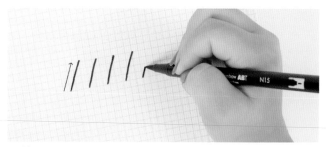

Making upstrokes.

THICK DOWN = DOWNSTROKES = APPLYING HEAVY PRESSURE

The goal for the downstrokes is to draw consistent "thick" lines when drawing lines from the very top and heading downward to the bottom.

Remember, when brush pens are brand new, the brush pen tip may feel stiff, allowing you to apply less pressure, but this is the perfect time to explore the brush pen and apply more pressure.

The goal is to let the brush pen do the work for you! Take this moment to angle the brush pen at a 45-degree angle and use the body of the brush tip or the "side" of the brush tip to achieve the thick downstrokes. This technique should be easier than applying heavy pressure using your wrist and body weight.

THIN UP = UPSTROKES = APPLYING LESS PRESSURE

When doing calligraphy, the goal for the upstrokes is to draw consistent "thin" lines by starting from the bottom and heading upward to the top.

I want you to be in control of the brush pen, so feel free to apply a little bit more pressure to avoid shaky lines, but remember, if your lines are shaky, it's totally normal. If you do notice that your upstrokes are a bit on the thicker side, feel free to explore and find a happy medium. You can always adjust by applying heavier pressure for your down-strokes, too.

Learning these strokes was hard for me in the beginning too, but as long as you keep practicing, I promise you that it will become much easier. To put things in perspective, if you practice these drills on a daily basis, by the end of the first week you should already feel comfortable with it since we are building our muscle memory.

tip When achieving your downstrokes, you'll notice the differing pressure levels from light, medium, and heavy pressure. Feel free to apply medium to heavy pressure when doing the downstrokes.

The Drills

DURING MY LETTERING JOURNEY, what has really helped me was first understanding the drills and feeling comfortable with them. I can promise you that there's a reason why these drills exist, but first, let's discuss the different types of drills that are helpful.

Downstrokes
Apply medium to heavy pressure starting from the top toward the bottom.

Upstrokes
Apply light pressure starting from the bottom toward the top.

V-Shape
Let's now combine both the downstrokes and upstrokes together. After drawing the downstroke, lift your pen to readjust your grip and draw the upstroke starting from where your downstroke ended. This specific drill should be drawn separately from your downstrokes to upstrokes and never in one continuous stroke.

Mountain Shape
Let's now reverse the V-Shape drill and start from the upstrokes to downstrokes. Remember to lift your pen and readjust your grip if you need to when making the transition from the upstrokes to the downstrokes.

N-Shape (Overturn)
During this drill, let's first start with our upstrokes (similar to the Mountain Shape) and then transition to the downstrokes, creating a curve between both strokes. It may help to also do this drill in two steps: Create the upstrokes first and then connect the lines together when completing the downstrokes.

U-Shape (Underturn)
With the U-Shape drill, let's first start with our downstrokes and then transition to the upstrokes, also creating a curve between both strokes as in the previously mentioned N-Shape. This drill is a bit trickier than the others, so feel free to start applying less pressure for your downstrokes about one third from the center point. You can also try this drill in two steps as also mentioned in the N-Shape.

O-Shape (Oval)
Let's now apply light/medium pressure starting at the top (center point) and immediately transitioning to apply heavy pressure for our downstrokes. Then transition to light pressure during our upstrokes. The goal is to not create perfect round circles, but more like ovals, and gain the understanding of how to create round shapes.

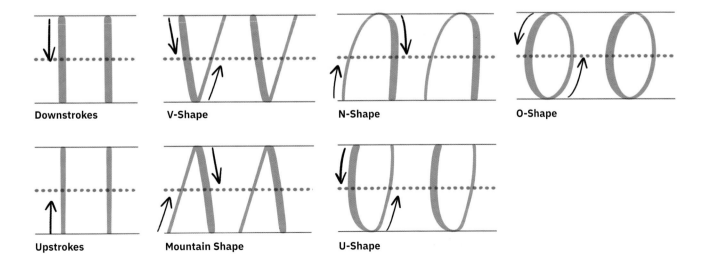

Downstrokes V-Shape N-Shape O-Shape

Upstrokes Mountain Shape U-Shape

Let's now practice a few warm-up drills by alternating the strokes from downstrokes to upstrokes and so on. These warm-ups are a good way to keep practicing that the strokes will always change from downstrokes to upstrokes or upstrokes to downstrokes when lettering.

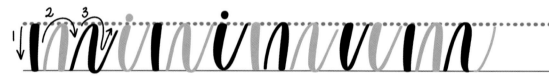

Practicing alternating strokes (downstrokes and upstrokes).

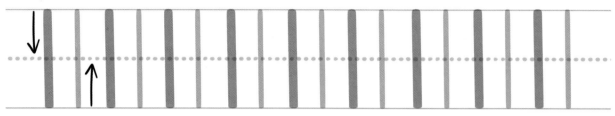

The word minimum consists of basic drills that we reviewed earlier. When you look closely, the downstrokes, overturns and underturns make a majority of the letters. For example, the downstroke is the first step to make the letter "m" (reference #1); the overturn is the second step to create the letter "m" (reference #2); lastly, another overturn followed by an underturn is drawn to complete the letter "m" (reference #3).

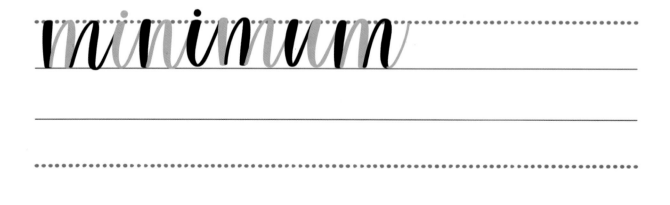

Reviewing Drills
& Lettering Guidelines

WHEN YOU TAKE A STEP BACK and review all the drills that we just practiced, a majority of the lines and shapes you just drew create actual letters. For example, when you combine a downstroke with the N-Shape (overturn) drill and play around with the size of the N-Shape drill, you can create the lowercase letter "h." Also, when you combine the O-Shape with the downstroke and add a curve at the end, it creates the lowercase letter "g." The combinations are endless, and multiple letters can be created when combining them together and stretching the shapes in different sizes and lengths.

A few examples of combining drills to create letters: g, n, m, and h.

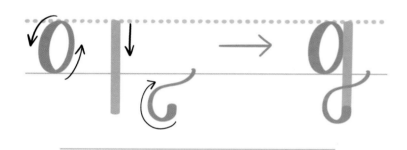

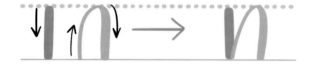

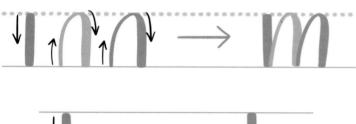

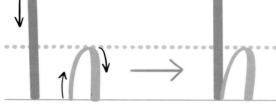

The goal when drawing the letters is to make sure every line is drawn with intention. For example, with every downstroke and upstroke drawn, try to draw each line individually and take a break before drawing the next line. Refer to the examples below.

- **Ascender** (top line): Where some letters ascend above the waistline (such as h)
- **Waistline** (second line from the top): Typically the height of lowercase letters and the beginning part of each letter (the a, some parts of the letter h, p, and y will share the same height as the waistline)
- **Baseline** (third line from the top): Where the bottoms of all letters meet (all letters in the example)
- **Descender** (fourth line from the top): Where some letters drop below the baseline (such as p and y)

Now that you have seen how to build and draw some letters, let's now introduce an overview of both uppercase and lowercase letters with a step-by-step breakdown.

OVERVIEW OF LETTERS

Both uppercase and lowercase letters can come in so many different styles, especially in modern calligraphy. Everyone has their own style by the use of flourishing, structure, and entrance and exit strokes. In the beginning, everyone needs a starting point. The more you practice, each stroke and letter will become easier to draw as your muscle memory develops. Your lettering style may look totally different from your Day 1 to your Day 14 to your Day 30, and so on. Enjoy exploring your style and this learning process. It's the most exciting part! For the example on the opposite page, the letters will appear in a more structured style to help you understand the anatomy of each letter. Throughout this section, we'll progress to create a more bouncy and loose style.

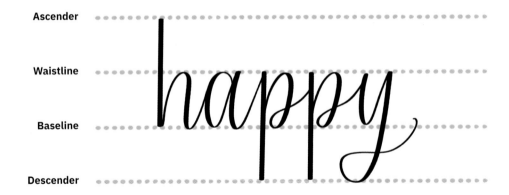

Ascender

Waistline

Baseline

Descender

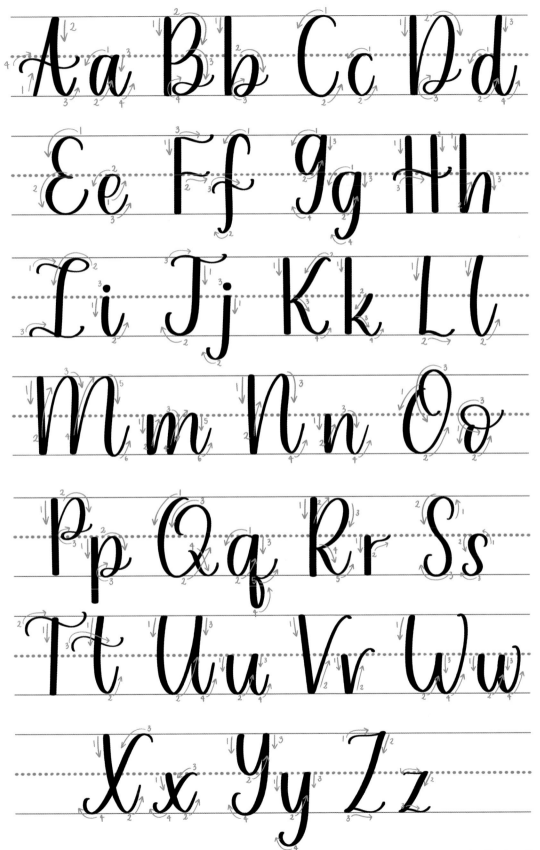

Connecting Letters

CONNECTING A LETTER to another letter can definitely be challenging because every letter is different. My advice to you is to focus on the exit strokes of each letter. The longer the exit strokes are and drawn away from the letter, the easier and smoother the connections of each letter will be. These exit strokes also help with the spacing of each letter, too. A majority of letters end with an exit stroke similar to the U-Shape (underturn) drill, such as the letters a, d, and h. Some letters can be more complicated than others, such as the letters o, p, and r. In the end, the goal is still the same and made easier by extending the exit strokes.

Refer to the image below highlighting the exit strokes. Notice that the exit stroke is extended and the following letter overlaps. This allows each letter to connect smoothly.

tip Practice a few connecting letters that appear challenging. The more you practice, it will become easier with time and patience, and your lettering will become much more fluid. Let's review a few examples together: the words "hi" and "love"!

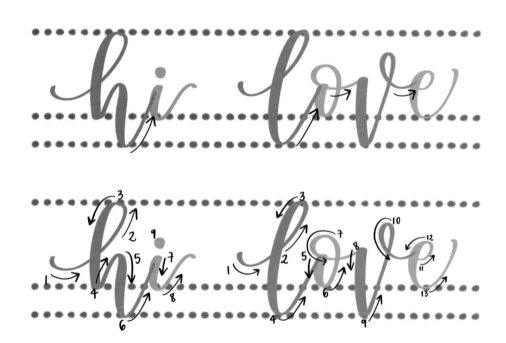

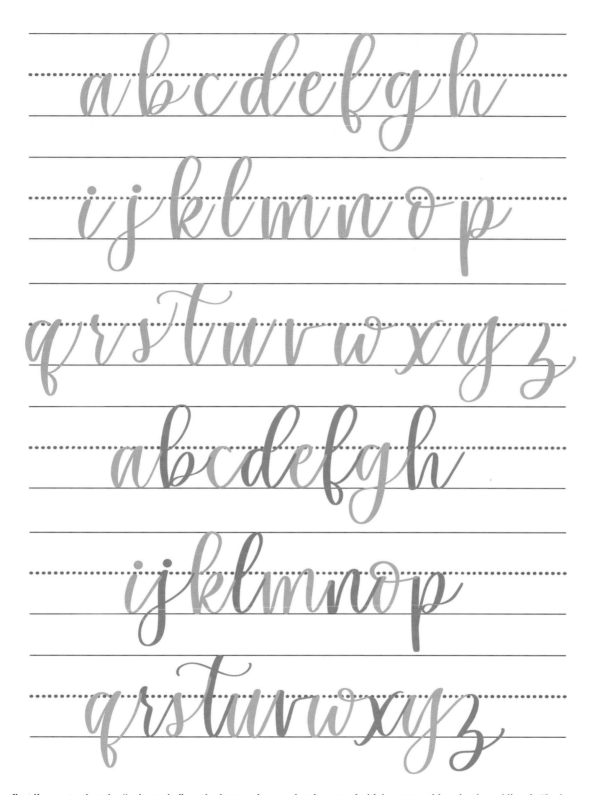

On the first line, note that the "exit stroke" on the letter a is completely extended (almost touching the dotted lines). The key to connecting letters is to extend the exit strokes. However, some exit strokes will be shorter or longer than others depending on the letter. The top set of letters from a-z in this image shows the letters extending the exit strokes before they are connected to the next letter. The bottom set of letters shows the letters connected to the one that follows.

Exploring Other Styles

Bouncy Lettering

This style definitely holds a special place in my heart because I absolutely love how loosely each letter flows. It also looks the most forgiving because it's not as structured and each letter will not fall on the same baseline. Earlier, I showed an example of the letters that had a more structured style. Now, let's revisit the basics and focus on the baseline. In a word with a bouncy style, we will be stretching or shrinking each letter to create a bouncy style. For example, depending on the letter, the first letter in a word is usually a lot taller with the second letter following appearing to be much smaller.

tip To understand bouncy lettering, refer to the image below. Notice how the word "hi" is written in a structured format on the left-hand side in comparison to the word "hi" on the right-hand side. The main goal is to acknowledge the baseline. In this example, the first letter of the word on the right-hand side dropped past the baseline to appear bouncier.

Now, let's practice together! Let's write the word "hello" in a bouncy style. In this example, I have numbered the lines 1 through 5. Lines 2 and 3 will be our center point. Let's first draw the upstroke for the letter "h" starting on line 3 and then stopping at line 1. Let's now transition to do the downstroke of the letter "h" starting from line 1 and ending at line 3. Starting from where we left off (downstroke of the letter "h"), let's now complete the letter "h" using the N-Shape. When this is achieved, we will be dropping below line 3 and completing the letter "h" on line 5 rather than stopping at line 3 where we first started, to create a bouncy style. The exit stroke of the letter "h" will be extended to help with the spacing of each letter and to connect the next letter more easily. The letter "e" will be smaller in size, falling on line 3. Next, the letter "l" will match the exact same size of the letter "h." The following letter "l" will be slightly smaller in size to create a bouncy style, which will be achieved between line 2 and 4. the height from line 2 and 4. Lastly, the letter "o" will match the same size as the letter "e."

When you take a step back, notice how the letter "h" and the first letter "l" have the same height and the letter "e" and "o" are about the same height also. The rule of thumb is to make sure the first letter is taller in size and the following letter is smaller in size and so on.

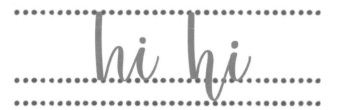

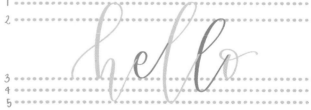

Here is another style of bouncy lettering that includes fun flourishes. Feel free to letter using a brush pen for additional lettering practice.

abcdefghijklmn

opqrstuvwxyz

Aa Bb Cc Dd
Ee Ff Gg Hh
Ii Jj Kk Ll
Mm Nn Oo Pp
Qq Rr Ss Tt
Uu Vv Ww Xx
Yy Zz

A bouncy lettering alphabet.

Loose-Style Lettering

This style is whimsical and fun. When creating loose style lettering, focus on those exit strokes—the longer they are, the easier it is to not only connect to the next letter, but it will help create a whimsical look. Also, it's important to create a similar exit stroke used for the first letter to ensure equal spacing and the creation of loose strokes.

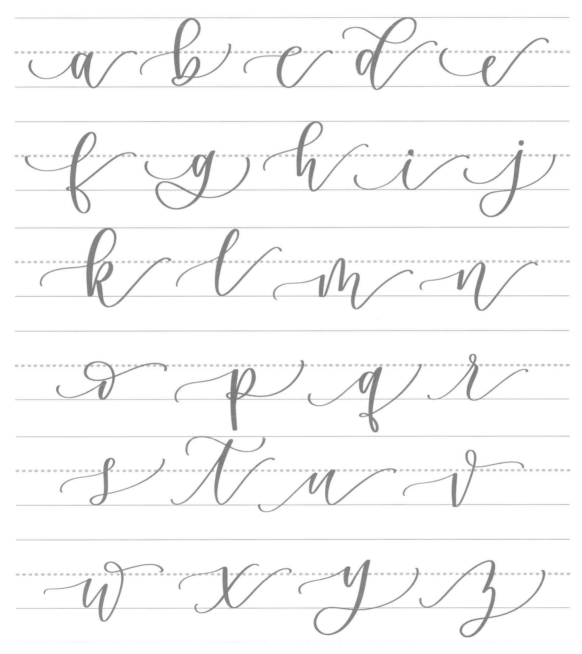

Here's an example of loose-style lettering, with each individual letter illustrating both entrance and exit strokes. However, if you would like to connect the letters "a" and "b" together, omit the entrance stroke for the letter "b," but proceed with the entrance/exit stroke for the letter "a" and exit stroke for the letter "b."

Double Letters

These can be tricky. My tip for double letters is to make the first letter appear larger and then the second letter appear much smaller. This also works in the opposite case, in which the first letter is smaller and the second letter is larger. However, a majority of letters can also be the exact same size, and that works, too (such as letters p and o). It's definitely all about your preference and the style you would like to achieve, but any option works.

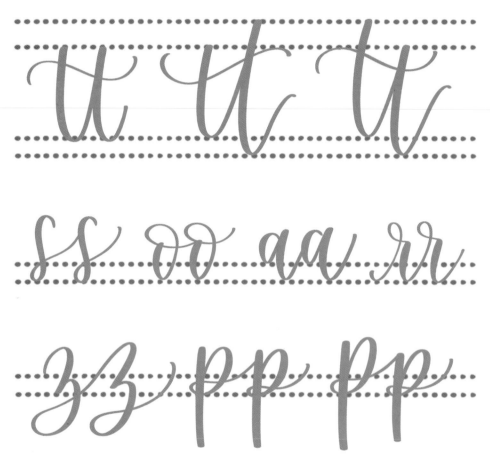

A few examples of double letters.

Flourishes

Adding flourishes to the beginning (entrance stroke) and exit stroke of a word definitely helps create a different style overall. Simple flourishes such as the U-Shape drill in a loose style could work for both entrance stroke and exit stroke of a word. Flourishes are super fun but can be tricky at first. I like to think of them as another art form, different from lettering. Although flourishing can be viewed as an advanced lettering technique, my goal here is to give you a preview and the ideas you need to get started. I strongly believe that when examples are shown earlier on it provides a better insight into the direction you want to go into with your lettering journey!

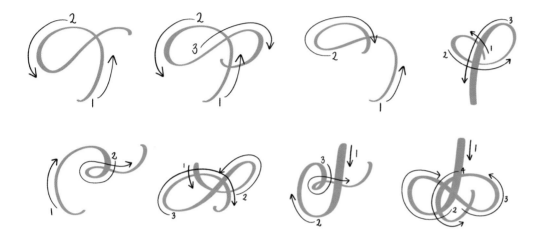

The first three flourish examples, starting from the left (top half), can be used after the exit stroke of a majority of letters that do not pass the "waistline."

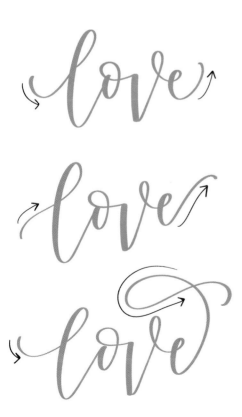

The arrows illustrate the entrance and exit stroke of each letter. Here are a few examples of the word "love" written in three different styles where the entrance and exit strokes start and end in various directions creating a different style. The last word "love" (located at the bottom) illustrates the similar entrance stroke as the first word, but ends with a completely different exit stroke known as a simple flourish.

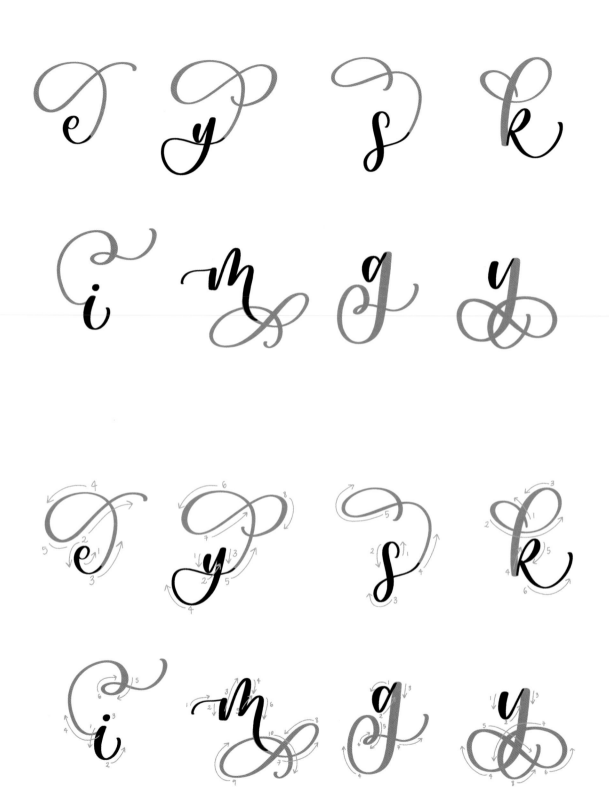

The flourishes on the previous page shown with letters (above) and a
step-by-step breakdown of each example.

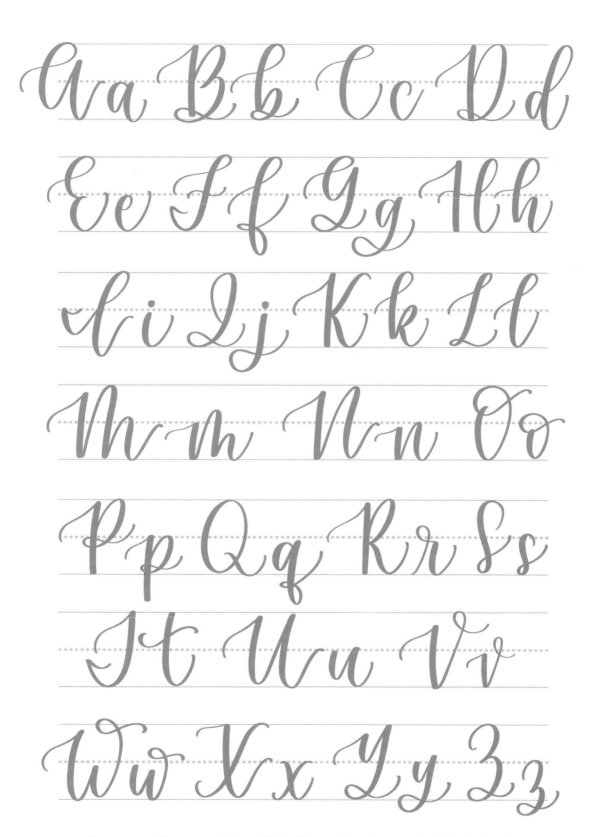

**Uppercase and lowercase letters with flourishes on the entrance and exit stroke of each.
Feel free to trace the letters for additional lettering practice.**

Simple Embellishments

Here are a few examples of simple embellishments I like to add below a word or phrase. These fun embellishments add a finishing touch and can sometimes create balance to the overall piece. I still apply light to medium pressure depending on the upstrokes and downstrokes of each flourish and embellishment.

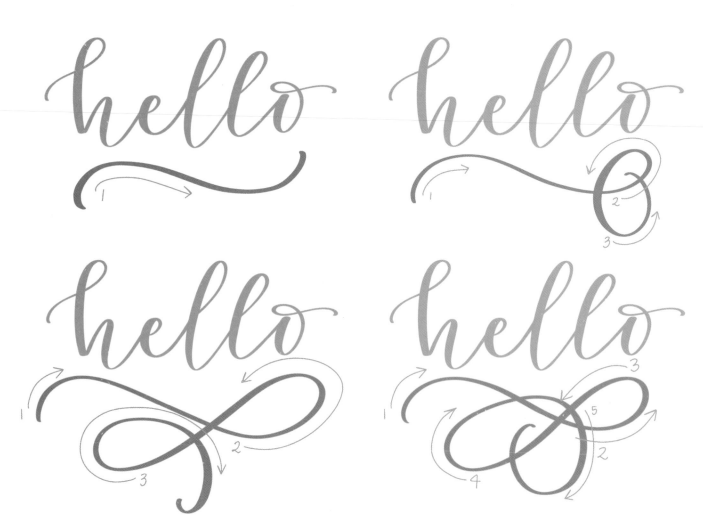

A few of my favorite embellishments.

Nonscript Capital Letters

Nonscript capital letters such as sans serif are a fun, unique style to incorporate when lettering longer quotes because it creates balance throughout the entire piece. For example, the first line of the quote can be in modern calligraphy and the second line of the quote can be in nonscript and so on. Each letter will have the same height and fall on the same baseline. When creating these styles, I'll still draw each line individually and with intention. When using a brush pen, for every downstroke of a nonscript capital letter, heavy pressure will still be applied.

LARGE BRUSH PEN

A B C D E F G H I J K L M
N O P Q R S T U V W X Y Z

Examples of nonscript capital letters/sans serif made with large and small brush pens.

A B C D E F G H I J K L M
N O P Q R S T U V W X Y Z

SMALL BRUSH PEN

A B C D E F G H I J K L M
N O P Q R S T U V W X Y Z

A B C D E F G H I J K L M
N O P Q R S T U V W X Y Z

Designing Quotes

Designing quotes and compositions can be challenging. But similar to with flourishing, my goal is to showcase a few of my favorite templates in order to help you get started with your lettering journey. When working on composition and placement of words, I like to use boxes as a template and guide. A few of my favorites appear below.

Keep in mind, when using these boxes, the lettering styles can be changed, too. For example, in the first box, the lettering style can be written in script or nonscript. The boxes can also be used as a guide to identify the negative space, which can be filled with a flourish/embellishment (for example: good vibes only). The possibilities for compositions and designing quotes are endless, but I hope these templates provide more of a visual guide and help with your lettering journey.

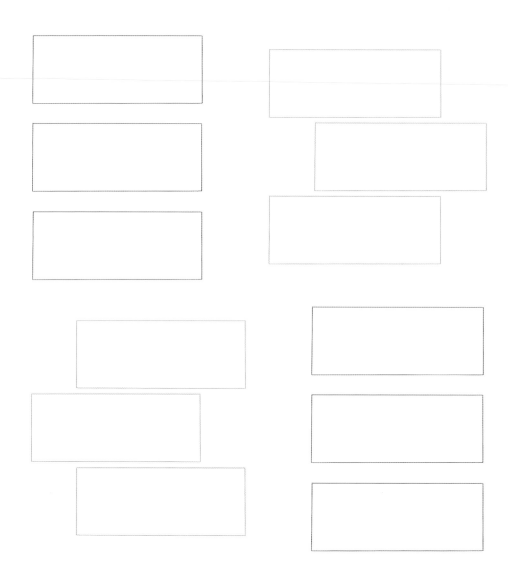

Layouts for four three-word quotes. *Imaginer c'est choisir*: To imagine is to choose (French; quote by Jean Genet).
Eile mit Weile: Haste makes waste (German).

Nunca

ES TARDE PARA

Aprender

2
digitizing your lettering

It's time to shift gears and transition to the next step: digitizing your hand lettering and artwork pieces.

Digitizing can help save time spent, especially when you want to create multiples of your projects. All you need to do is hand letter the piece, then scan or shoot, make adjustments as desired, and print.

Digitizing your artwork pieces also gives you the flexibility to create your piece into a digital file, which allows you to print the artwork pieces on a larger scale without losing the quality of the actual artwork piece.

Nunca es tarde para aprender: It's never too late to learn (Spanish).

Overview

IN THIS CHAPTER, I demonstrate several options step-by-step for the digitizing process.

There are so many technical steps and processes for digitizing, scanning your lettering, and manipulating it digitally, whether you're making multiples or adjusting color, texture, and/or size. However, the digitizing process can range from being simple to very complex. I've tried multiple variations and found the best processes that work for simple digitizing. Throughout this chapter, we review multiple variations of digitizing, but the steps will also be simple and straightforward, discussing only the essentials you need to know about the digitizing process.

The following techniques and programs are covered in this chapter:
- Scanning directly using a flatbed scanner
- Taking a photo of your lettering art piece with a camera or smartphone
- Using Silhouette Studio and Adobe Illustrator. I absolutely love using Illustrator to create a digital file of my entire lettering piece.
- Reasons for using Adobe Photoshop. I recommend using Photoshop for editing photos and digitizing backgrounds and images that complement the lettering pieces.

To start the digitizing process, you need to upload the lettering artwork to your computer before using programs such as Silhouette Studio, Illustrator, and so on.

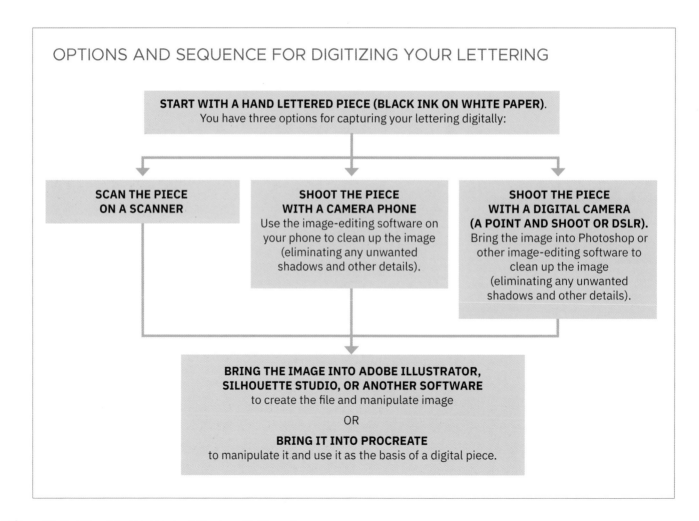

OPTIONS AND SEQUENCE FOR DIGITIZING YOUR LETTERING

START WITH A HAND LETTERED PIECE (BLACK INK ON WHITE PAPER).
You have three options for capturing your lettering digitally:

SCAN THE PIECE ON A SCANNER

SHOOT THE PIECE WITH A CAMERA PHONE
Use the image-editing software on your phone to clean up the image (eliminating any unwanted shadows and other details).

SHOOT THE PIECE WITH A DIGITAL CAMERA (A POINT AND SHOOT OR DSLR).
Bring the image into Photoshop or other image-editing software to clean up the image (eliminating any unwanted shadows and other details).

BRING THE IMAGE INTO ADOBE ILLUSTRATOR, SILHOUETTE STUDIO, OR ANOTHER SOFTWARE
to create the file and manipulate image

OR

BRING IT INTO PROCREATE
to manipulate it and use it as the basis of a digital piece.

Capturing Your Lettering

IN THIS PROCESS, create your lettering piece using a black brush pen on white paper. The high contrast between the pen and the paper will make it easier for the flatbed scanner or camera lens to pick up the lettering piece.

Option 1: Scanning on a Flatbed Scanner

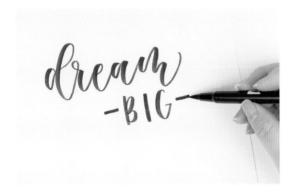

1 Use a black brush pen to hand letter a word or phrase on a clean sheet of white paper.

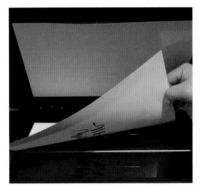

2 Place the lettering piece face down on the flatbed scanner. Use a scanning program on your computer to scan the lettering piece.

3 Select the desired area for the lettering piece. In the scanning program, select the image as a "black and white photo." This setting will help scan the lettering piece and create smoother lines because it will be recognized as a photo. For the DPI, select 300. For the format, select TIFF, PNG, or JPEG.

4 Select **Scan** and save the image. You're all set with the scanned piece, which you can then open in any of the programs discussed for digitizing in the next section (see page 44).

Option 2: Photographing with a Smartphone

1 Use a black brush pen to hand letter a word or phrase on a clean sheet of white paper.

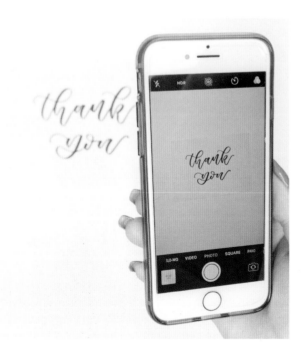

2 Place the lettering on a flat surface. Use your smartphone to photograph it.

3 Review the photo and access the photo edit settings to start the next process.

4 Crop the image to eliminate most of the white area around the lettering so the lettering becomes the focus of the image. Adjust the light settings to increase the contrast so the lettering piece can be recognized more easily when it's brought into an image-editing program.

SMARTPHONE ALTERNATIVE: Photographing with a Digital Camera

This process is very similar to using a smartphone, except you'll need to take it a step further.
Since you won't be able to make any edits in the camera, you'll need to upload the image to your computer and prep it in Adobe Photoshop or similar software.

1. Repeat step 1 from Option 2. Place the lettering piece on a white surface, ideally directly under the light to avoid capturing any harsh shadows.

2. Shoot the piece with a digital camera, angling it slightly to avoid any harsh shadows.

3. Upload the image to your computer (via a USB cable, for example).

4. Open the image in Photoshop (or other image-editing software) and import it to the canvas. Eliminate any harsh shadows and increase brightness and contrast as needed so the image appears black and white.

5. Once the image has been edited, you can use it to create a digital lettering file in either Adobe Illustrator or Silhouette Studio (see page 44).

Creating a Digital Lettering File

CREATING A DIGITAL FILE of your lettering gives you many creative options, including making multiples in a variety of colors and changing the sizes and shapes of the letters.

I cover two software options in this section: Adobe Illustrator and Silhouette Studio.

Working in Adobe Illustrator

1. Using Illustrator on your computer, upload a photo to digitize.

2. Click on the photo, which will show the image menu at the top of the screen.

3. In the image menu, click on **Image Trace**. This should create a digital file and automatically find the lettering and create paths for the lettering to be adjusted **(A)**.

4. Click the drop-down menu **View** after the image trace has finished and choose a view (in this example, "Outlines" is selected) to see if the resulting trace is correct **(B)**.

5. Click **Expand** to confirm that the image traced is correct and that the image is now ready to be adjusted, if needed. There should be a thin colored outline.

6. At this point, the lettering is now created into a digital file. (Note: The result is similar to cutting out the lettering by hand, separating it from a piece of paper; therefore, the original image and a new digital file are both existent.)

7. Using the **Direct Selection Tool**, click on each piece not needed (the negatives of each letter) and delete it; we will not be using them **(C)**.

8. Using the **Selection Tool**, click on the lettering. This allows for you to enlarge, reduce, or copy it without affecting the quality of the image. The outline in red showcases the text being stretched out as an example **(D)**.

9. Clean up the workspace and save the file after adjusting it to your preference. This file can now be used for anything, such as printing on a larger scale.

(A)

(B)

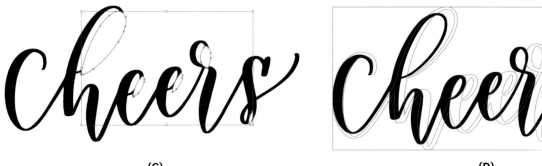

(C)

(D)

Working in Silhouette Studio

This is a great option if you don't have access to a scanner or to image-editing software like Adobe Illustrator or Adobe Photoshop. All you need to do is photograph your lettering and then bring it into Silhouette Studio, a free, downloadable computer app available on the Silhouette America website.

What You'll Need

- **USB flash drive (optional)**
- **Computer**
- **Silhouette Studio software (download at www.silhouetteamerica .com/software)**

1 Create a digital image of your lettering by following steps 1-5 for Option 2: Photographing with a Smartphone (see pages 42-43). Upload the image to your computer, either via a USB flash drive or by emailing it to your personal email. Open the Silhouette Studio program. Upload the photo to the canvas by dragging the image from your flash drive or email into the Silhouette Studio program. You can make your canvas any size; the canvas shown is 8.5 × 11 inches (21.6 × 28 cm) landscape.

tip Although the steps are different when using each program, there are various other programs that can be used to create a digital lettering file. In this example, I share my experience using Silhouette Studio, but other programs such as Cricut Design Space can also be used to create digital lettering files.

2 To create a digital file: **(A)** in the **Trace** screen, click on **Select Trace Area**; **(B)** use the mouse to click and select the area; and **(C)** deselect the setting **High Pass Filter**. Click on **Trace**.

3 Note that once the lettering is traced, it will be outlined in red.

4 Click on and delete the original image, leaving only the traced lettering. Delete the background image by clicking on the imported image and then pressing delete.

5 Once the lettering is created into a digital file, you can enlarge, reduce, or copy it without affecting the quality of the file.

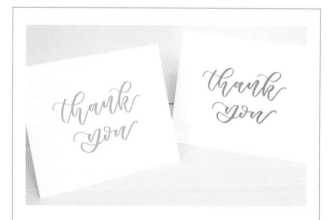

MAKE IT A PROJECT

Save the digital file and use it to make prints, cards—anything you like. You can also use it with a Silhouette Cameo machine to create vinyls (see page 120).

6 You can easily change colors after resizing or copying the lettering.

3

Lettering on a Tablet

When I first started lettering on a tablet, I found it interesting because it was very different from using brush pens and paper. I kept experimenting over and over again to understand the basic features and, of course, to get comfortable lettering on a new surface.

After experimenting, I fell in love with using the iPad Pro paired with the Apple Pencil and using the Procreate app for lettering, illustrations, and doodles. I'll be honest: When you're using a new medium, there may be a learning curve, especially with the iPad Pro, but don't worry—we will explore the Procreate app together step by step. Once I understood how to use the Procreate app and create lettering pieces, I now take my iPad Pro with me everywhere and basically letter on the go!

Essential Tools

THIS CHAPTER WILL REVIEW THE BASIC FUNCTIONS I often use when using the Procreate app for lettering. It may seem overwhelming and a lot of information up front. You'll be able to explore and experiment with a range of features through the step-by-step techniques in this chapter and the projects in chapter 4.

In this section, the iPad Pro and Apple Pencil will now be our lettering essentials. The iPad Pro with the Procreate app will be the canvas "paper" we will be using and the Apple Pencil will be our "brush pen." We will also discuss Procreate's features and how to get started.

I absolutely love using the iPad Pro, Apple Pencil, and Procreate because after trying out multiple brands and tablets out there, I love how travel-friendly the iPad Pro is and how easy it is to use the Apple Pencil paired with the iPad Pro. One of the many things I noticed was that I can achieve defined strokes using the iPad Pro, Apple Pencil, and Procreate, and I appreciate how responsive the Apple Pencil is when using the Procreate App. These essential tools have helped me achieve detailed artwork and lettering pieces.

The Apple iPad Pro and Apple Pencil.

OTHER TABLETS/STYLUSES

Aside from the iPad Pro and Apple Pencil, there are other options for creating digital lettering. To explore the effects shown in this book, you'll need a combination of software, tablet, and stylus that produces variation in line by changing the pressure on the stylus and lets you create various effects. If you work with other digital tools, the steps won't be the same as shown, and you may not be able to reproduce some effects. I've done all my digital lettering on an iPad Pro and with an Apple Pencil, but other digital lettering artists use Wacom Bamboo, Microsoft, and Samsung tablets and the FiftyThree Digital Stylus and the Wacom Bamboo Stylus, which works with the "regular" iPad (not the Pro). Many other tablet and stylus brands are available; I recommend that you test them before purchasing, and visit online forums to see what users are saying about them.

Getting Started in Procreate

SO, WHAT IS PROCREATE? Procreate is an app that allows anyone to design and be creative by giving them the ability to create illustrations, doodles, sketches, painting artwork pieces, and so much more using the canvas and brushes from Procreate.

Opening Procreate

When you open the Procreate app, you'll see the layout at right.

- The **Select** button on the upper right-hand corner allows you to select files to Stack (similar to merging all the selected files in one folder), Preview, Share (AirDrop to other Apple devices such as Apple Computer and Apple Phone, email, text, and more), Duplicate, and Delete artworks.

- The **Import** button (located next to the Select button) allows you to import files.

- The **Photo** button allows you to access your photo library on your iPad Pro, and once a photo is selected, it will be created into its own canvas on Procreate using the photo dimensions.

Opening a New Canvas

1. Open the Procreate app.

2. Tap the **+** located in the upper right-hand corner.

3. Tap on **Create Custom Size (A)**.

4. Choose the right canvas size for your artwork. The canvas size will vary depending on the artwork you would like to create. When I'm working on a detailed, colorful piece, whether it's an illustration or a lettering piece, I definitely consider using the pixels that will give me the best resolution. However, for simple lettering pieces we'll be creating throughout this book, I personally recommend the canvas size to be 8.5 × 11 inches (21.6 × 28 cm) with a DPI of 300 **(B)**.

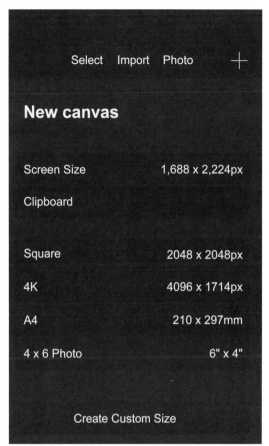

(A)

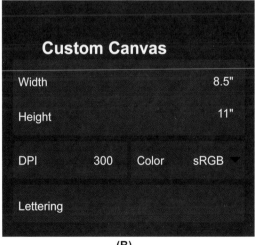

(B)

Quick Overview of Common Functions

Here's a **quick overview of the common functions for lettering** on the Procreate app:

A: Gallery. By tapping on this, the main menu will appear and exit the canvas.

B: Actions. A majority of the importing image functions and saving artwork projects will take place here.

C: Adjustments. These are effects for the artwork pieces.

D: Selection tool. This is used to select specific areas of the artwork.

E: Transform tool. The entire artwork on the layer being used will be selected.

F: Brushes. Thes are used to create the artwork pieces and hand-lettering pieces.

G: Smudge. This is a great tool to blend colors together, change the direction of the color, and add texture.

H: Eraser. This not only erases your artwork but it also allows you to select an erasing lettering brush.

I: Layers. The layers will be extremely helpful, as different parts of your project can take place in different layers.

J: Color wheel. The wheel allows you to select specific colors to recolor your text, to color with, and much more.

K: Brush size %. You can achieve strokes in differing base thickness by increasing or decreasing the brush size.

L: Color selection. This allows you to choose the same colors already used on the canvas. I love using this function because I always tend to forget the color I selected when creating artwork pieces and this function helps me select the same color I used before.

M: Brush opacity %. You can change the opacity of the brush's color, which can add some cool effects.

N: Undo (top arrow) and **Redo** (bottom arrow)

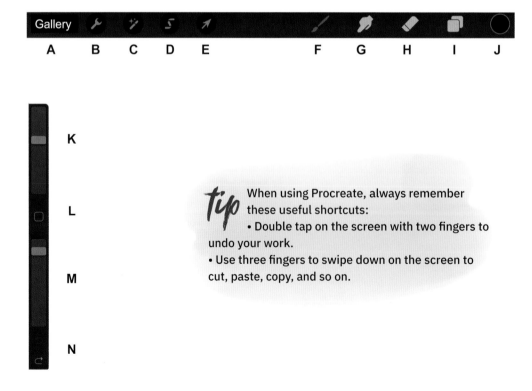

tip When using Procreate, always remember these useful shortcuts:
• Double tap on the screen with two fingers to undo your work.
• Use three fingers to swipe down on the screen to cut, paste, copy, and so on.

Learning the Basics

AFTER EXPERIMENTING with the Apple Pencil on the Procreate app, you may notice that a few of the brushes will react to different pressures, while other brushes won't. For example, in the "Calligraphy" folder under brushes, the Monoline brush won't react to pressure. However, the Brush Pen brush will react to pressure when heavy or light pressure is being applied using the Apple Pencil.

This is something to keep in mind when deciding which brush to use for lettering. Always remember the basic rules for modern calligraphy: Downstrokes will be thick lines (heavy pressure) and upstrokes will be thin lines (light/ medium pressure). This fundamental idea also applies when lettering on the iPad Pro using the Procreate app and Apple Pencil.

Let's explore! Feel free to take time to experiment with the Brush Pen. Open a new canvas, adjust the brush size if needed, and create a few downstrokes and upstrokes to get a better understanding of the differing pressure levels.

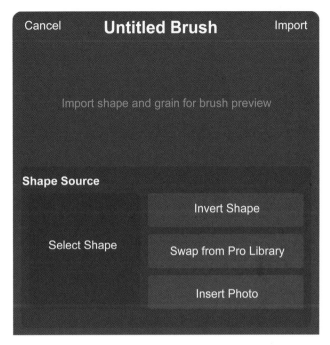

Creating a Simple Lettering Brush

Even though I absolutely love the brushes that are already provided in the Procreate app, I think it's also fun to create your own brushes! Together, let's create a simple lettering brush.

1 Tap on the "Brush Library" button. You can also create your own custom folder: On the left-hand side, swipe down until you see the "+" button (highlighted in blue) located beneath the text "Brush Library," which will allow you to create a folder to store your custom brushes. Rename the file.

2 Now, once the custom brush set has been created, at the upper right hand corner, select the **+** symbol. Feel free to tap where it says **Untitled Brush** to rename your custom brush. For the **Shape Source**, select **Swap from Pro Library**. The Shape Source will give the shape of the brush, and the Pro Library is a library provided by Procreate where you can access various shapes and backgrounds.

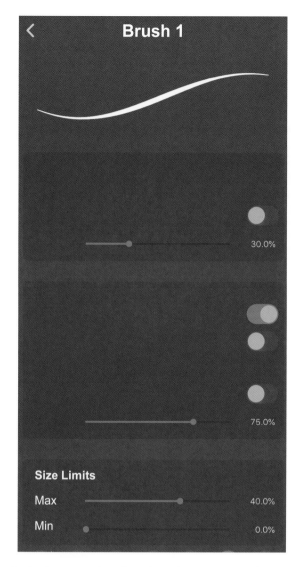

3 Find and select the **Oval** shape. Next, select **Grain Source**, which will add texture to the custom brush, and select **Swap from Pro Library**. Scroll all the way down and select **Blank** for the background for Grain Source. Note: When making custom brushes, always make sure that the Grain Source has a solid background (no shapes).

4 Let's now make a few alterations to your custom brush to make it similar to a brush pen. At the very bottom of the custom brush panel, select the **General** tab. Only change the **Max** located in the **Size Limits** section, which controls the thickness of the brush, to about 40%.

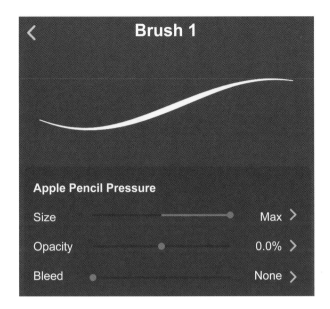

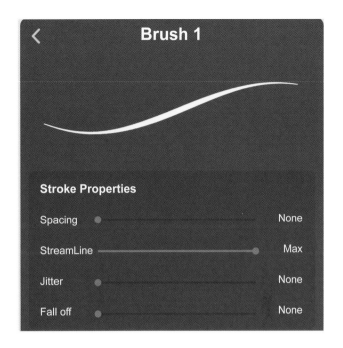

 5 Next, select the **Pencil** tab and adjust the **Size** located in the **Apple Pencil Pressure** section to the maximum, which controls the entrance and exit strokes.

 6 Lastly, on the **Stroke** tab adjust the **Streamline** located in the **Stroke Properties** section to the max and adjust the **Spacing** to 0% in order to create smooth, solid lines with no spaces in them.

Awesome! You're all done, having now created a lettering brush! Feel free to test it out and start creating more fun brushes, using the Pro Library for practice.

Testing Your Custom Brush

Using your Apple Pencil, let's now test out the pressure levels with your new custom lettering brush. You may have to adjust the **Brush Size** on the left-hand side to adjust the thickness to match the canvas dimensions. In the example below, notice that the lines vary in thickness:

- Based on our canvas size, 8.5 × 11 inches (21.6 × 28 cm), the downstroke located on the far left is much thicker than the rest. The brush size is at 100%.
- The downstroke located in the middle is about 25%.
- The downstroke located on the right is about 10% for the brush size.

At this time, you should have an idea of the brush size you prefer. There's definitely no right or wrong answer; it's all about preference and the style you'd like to achieve!

When creating downstrokes and upstrokes on the Procreate app, remember that using the iPad paired with the Apple Pencil allows you to achieve thick and thin strokes, similar to modern calligraphy:

- For thick strokes, feel free to tilt the Apple Pencil at an angle and apply heavy pressure going down.
- For thin strokes, hold your Apple Pencil straight up or at the same angle as when creating thick strokes, but now apply less pressure.

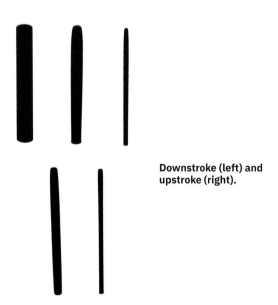

Downstroke (left) and upstroke (right).

Practice Strokes

Let's now practice a few strokes, being mindful of the downstrokes and upstrokes.

Below, I wrote a few letters: "h, m, n and v." The downstrokes (thick lines) and upstrokes (thin lines) are noticeable at each transition.

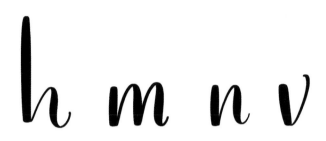

Let's now write a word, keeping in mind of the downstroke and upstroke transitions.

While I encourage you to explore on your own, I've included tricks I've learned while using Procreate that will come in handy as you progress in your journey.

Making a Straight Line

Using your Apple Pencil, draw a wavy line or a rough line (it doesn't need to be straight) and without lifting the Apple Pencil, continue to apply pressure on the iPad screen. The Procreate app will perfect, straighten, and smooth out the line you were creating.

 If your Apple Pencil is still on the screen—that is, if it hasn't been lifted off the screen once the straight line was corrected—you can move the line around by moving your Apple Pencil across the canvas.

 In the example to the right, notice how the wavy line on the left-hand side turned into the straight line on the right-hand side.

Making a Round Circle

Similar to the straight-line technique, when you draw a circle on Procreate, as long as the Apple Pencil isn't lifted off the screen, the Procreate app will perfect and smooth out the shape into a true circle.

 Refer to the example, to the right, where the circle was drawn (freehand) on the left, and then perfected on the right.

Filling Words & Shapes with Color

1 At the upper right-hand corner where the Color button is located (make sure the color currently selected is different from the text), using your Apple Pencil, tap and drag the color onto the canvas, hovering over the text.

2 Lift your Apple Pencil off the screen, and the text should now have captured the color. Imagine that you dropped paint onto your canvas: That's exactly what was done here where the color was dropped into the text.

When filling shapes, make sure the shape is connected and has no openings. Using the same technique, tap and drag the color inside the shape.

Picking Color from the Picker

I love using this technique because, often times, I randomly choose colors using the color wheel, not knowing what color I selected. The color picker gives you the ability to find the color that was used.

1. Tap on the box located in the middle of Brush Size and Opacity on the left-hand side. A circle that almost resembles a magnifier should pop up on the screen.

2. Drag the circle onto the text until you see the color you're looking for and make sure half of the circle (magnifier) is filled with the color you selected **(A)**.

3. Lift your Apple Pencil off the screen. You should now notice that the color has been selected at the upper right-hand corner (located in the color wheel button).

(A)

Showing Layer Functions

FILLING LAYER (ENTIRE SCREEN)

1 In the **Layers** tab, tap on Layer 1 (mine has been renamed to reflect the number 1); a drop-down menu should show up on the left-hand side that list Rename, Select, Copy, and so on.

2 When Fill Layer is selected, the entire screen will be filled with the currently selected color shown on the Color tab.

USING ALPHA LOCK TO CHANGE COLORS AND FILL LAYER TO CAPTURE TEXT ONLY

The Alpha Lock feature helps when you want to color only the text rather than the entire layer.

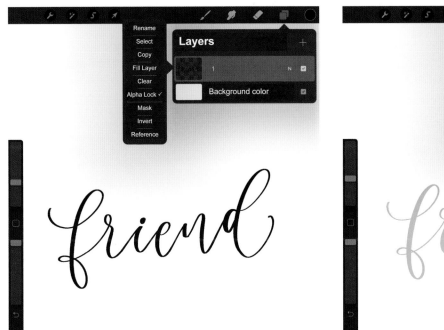

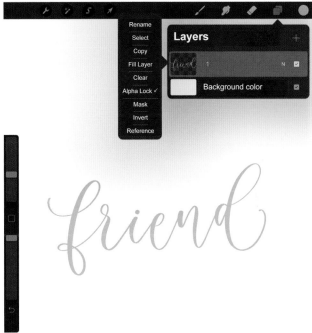

1 The Alpha Lock option basically locks the text into place. Once Alpha Lock is selected, you should notice a checkered background on Layer 1. You can also use two fingers and swipe to the right on the layer you want to Alpha Lock.

2 Once the layer is on Alpha Lock, select **Fill Layer**. Notice that the text was only recolored to the color that was currently selected on the Color wheel.

DUPLICATING LAYERS

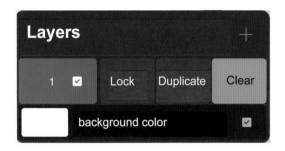

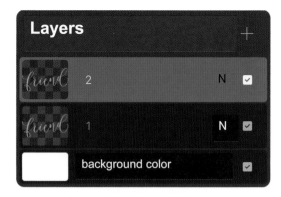

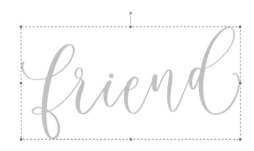

1 On layer 1, swipe to the left. You'll notice a few buttons: Lock, Duplicate, and Clear.

2 Select **Duplicate** for this example. On the Layers tab, you should now see two layers that look identical. I renamed my layers for the purpose of this example as 1 and 2.

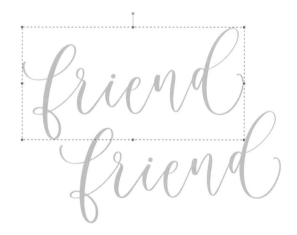

3 Make sure to tap on Layer 2 and select the **Selection** tool, noting that the word "friend" is boxed.

4 Using your Apple Pencil, feel free to move the text however you like around the canvas. This is a technique I often use to manipulate and move around my text.

MOVING MULTIPLE LAYERS TOGETHER

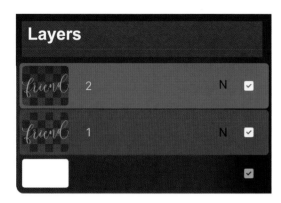

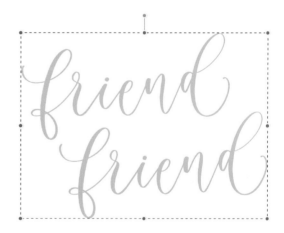

1. When one layer is selected (highlighted in blue), use your Apple Pencil and swipe right on another layer that is not highlighted in blue. Now the layers selected should be highlighted in blue (one layer might appear a bolder blue color and the other layer should be a faint blue color).

2. Next, using the Selection tool, the entire text should be boxed. You can now freely move the text around the canvas however you like by centering, resizing, and so on. This is a great way to continue to work on different layers but also have the ability to move the text/layers around all at once rather than individually.

Selecting Specific Text with Selection & Transform

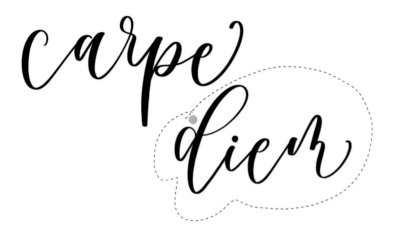

1 Open the **Selection** tool (make sure the setting is in **Freehand** located at the bottom of the screen). Use your Apple Pencil to draw a circle around the text you wish to transform (resize, move around, and so on).

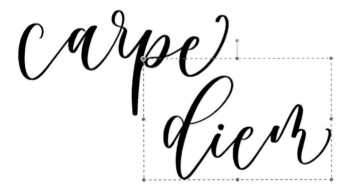

2 Once the text is selected, select the **Transform** button, which should box the text.

Carpe diem: **Seize the day (Latin).**

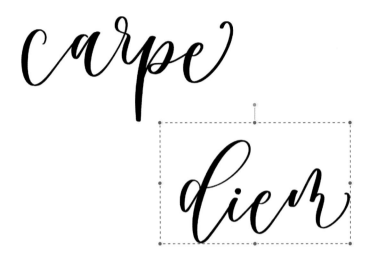

3 Now that the text is boxed, you have the flexibility to flip the text horizontally or vertically, resize, or rotate to your preference (by using tools located on the bottom toolbar or using two fingers to zoom in and out on the screen for resizing). Keep in mind that the more you zoom in and out and repeat the steps, it could lower the quality of the text. I definitely recommend resizing to your preference and then opening up a new layer to trace the resized text again to ensure the best quality.

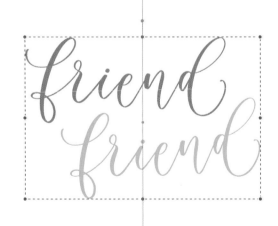

This feature works great when your goal is to only move a few words in the artwork piece. Note: After selecting the **Transform tool** , select the **Magnetics** button at the very bottom of the screen, which will give you the flexibility to move the text around in a straight line and center the text using lines to guide the movements.

Creating a Stamp
on the iPad Pro

I love making stamps because they definitely come in handy for projects!

1 On the Procreate app, letter a word or letter on a new layer (use the color black on a white background for the lettering). Select the **Actions** tool to share the image. Save the image as a PNG and save to your iPad's photo library. Select the **brush** tool and at the upper right-hand corner, select the **+** symbol. Feel free to rename the stamp.

2 In the Shape Source, select **Insert Photo**. This will now access your iPad's photo library. Select the lettering image we just saved, then select **Invert Shape**, which will make the background color black and the lettering text white. Next, for the Grain Source, select **Swap from Pro Library**. Select the Blank image for the Grain Source.

3 Select the **General** tab at the very bottom (located next to Source on the left). In Brush Properties, select **Use Stamp Preview**. Lastly, increase the Max to the highest in size limits.

Awesome— you're all done! Your stamp is now finished! Have fun with it!

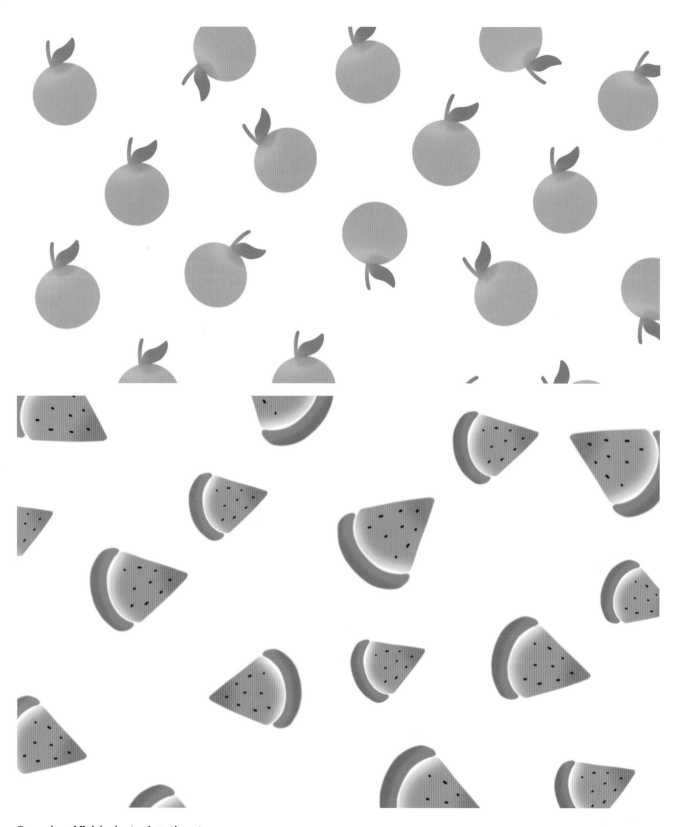

Examples of finished art using other stamps.

Essential Procreate Techniques

HERE ARE SOME GREAT TECHNIQUES using the iPad or iPad Pro, an Apple Pencil, and the Procreate app.

Creating Shadow Effects

I enjoy creating different shadow effects for my lettering pieces using the Procreate app because the process only takes a few minutes or less and it adds a nice finish to the artwork piece. Throughout this project, we will focus on working with the layers by duplicating and recoloring the lettering to create the shadow effects.

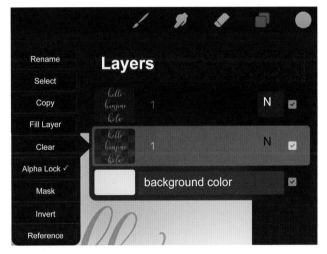

1 In the Procreate app, letter one or a few words on a new layer (any color) using your Apple Pencil. I used the simple lettering brush we created on page 53.

2 Then, open the **Layers** tab and swipe to the left to duplicate the layer. Two layers should now appear. On the original layer, tap the layer and select **Alpha Lock** in the drop-down menu or use two fingers to swipe to the right. Once the background inside the layer has a checkered effect, the layer is Alpha Locked.

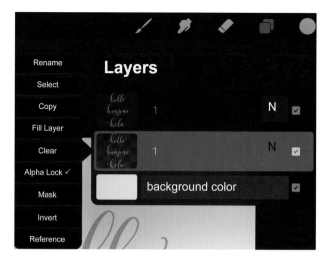

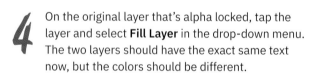

3 Open the color wheel in the upper right-hand corner and select another color that will contrast well for a shadow effect. In this example, I chose the color teal.

4 On the original layer that's alpha locked, tap the layer and select **Fill Layer** in the drop-down menu. The two layers should have the exact same text now, but the colors should be different.

5 Make sure the original layer is selected, tap the **Transform** tool, and use your Apple Pencil to gently tap on the screen to the right. Do *not* resize the original layer when using the Transform tool; just gently tap the screen to the right. The other color that was selected for the layer should now appear, showing a nice contrast.

This effect is perfect for prints, card making, invitations, and so much more!

Using Glitter Images

This technique is a fun way to complement your lettering pieces by using glitter images found online. However, any photo can be used for this technique. The overall goal for this project is to understand and learn how to screen images that will capture your text. This technique is perfect for handmade cards, invitations, prints and so much more!

GLITTER TEXT ON A WHITE BACKGROUND

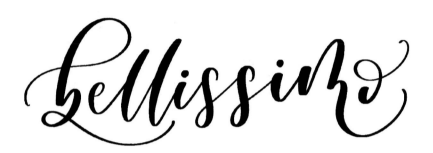

1

Using your Apple Pencil, letter a word or phrase on a new layer with the color black using either the simple lettering brush we created in the previous section (see page 53) or your favorite Procreate brush.

2

Search for a free high-resolution glitter image, then save it to your iPad. Now, select the **Actions** tab and choose **Insert a photo**. The image will automatically open on a new layer.

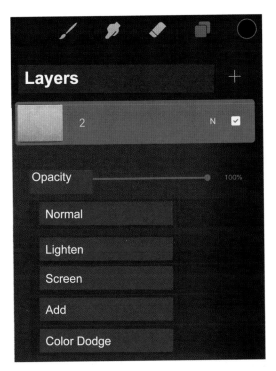

3 On the layer that contains the glitter image, use your Apple Pencil to tap on the letter "N," which is located next to the checkmark on the far right of the layer. (Note: The checkmarks can be turned on and off by simply tapping them with your Apple Pencil. If the layer is deslected the layer becomes hidden.) Once the "N" is selected, a drop-down menu will appear. Select the **Lighten** tab at the very bottom of the drop-down, and select **Screen**, which will make the text transparent, allowing the glitter background to show along with the white background.

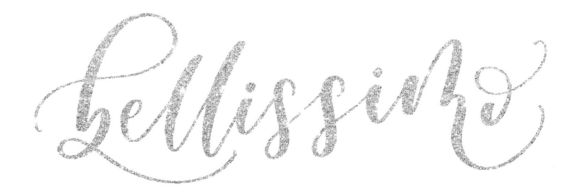

4 The hand lettering now has a glitter effect along with a white background.

Bellissimo: **Very beautiful (Italian).**

GLITTER TEXT ON
A BLACK BACKGROUND

When the background is the color black, the process is slightly different.

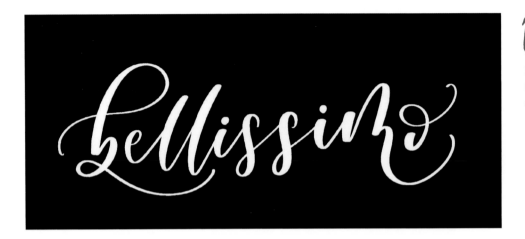

1

Hand letter the word or phrase using the color white.

2

Import the glitter image from the previous process using the Actions tab. Select the "N" again on the far right of the layer and select **Multiply** located in the Darken tab. Selecting the Multiply tab serves a very similar process to the screening effect mentioned in the earlier process.

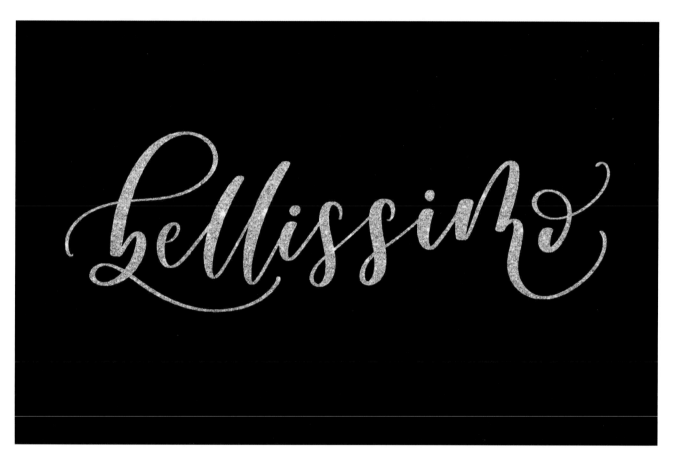

3 The hand lettering text now has a glitter effect
along with a black background.

Bellissimo: Very beautiful (Italian).

Creating a "Gold Foil" Effect Using Shades of Yellow

This project is one of my favorites because I love how simple this technique is; it's also unique to pair two different colors together and watch the colors blend beautifully using the Gaussian Blur setting. This example showcases the use of two different shades of yellow to give the illusion of a "gold foil" effect.

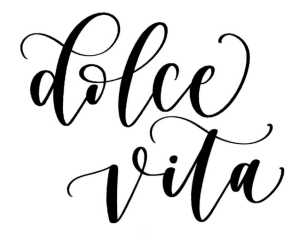

1. On a new layer, letter a phrase or word using your apple pencil and your favorite Procreate brush. In this example, I'm using dimensions 8.5 × 11 inches (21.6 × 28 cm) and the simple lettering brush we made in the previous section (see page 53).

2 Alpha lock the lettering layer. Open the Brush Library. Select the **Airbrushing** set from the Brush Sets list and choose **Hard Brush**. Feel free to increase the brush size on the left-hand side to about 7 to 10%. Open the Color wheel and select a dark shade of yellow. Draw a few strokes on top of the lettering piece.

3 Now, select a lighter shade of yellow and draw a few more strokes. The overall piece should now have a color pattern starting from dark yellow, light yellow, etc.

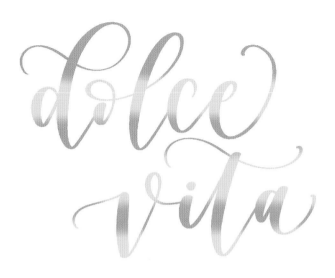

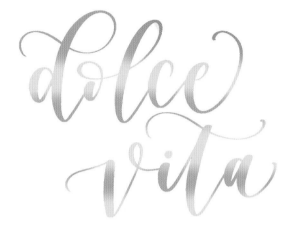

4 Select the **Adjustments** tab and choose **Gaussian Blur**. Gently glide your Apple Pencil across the tablet screen to the right. I stopped once I reached about 20% while using the Gaussian Blur setting. You can also take the effect a step further by adding a shadow of any color.

5 To add a shadow, open the **Layers** tab and duplicate the lettering layer, making sure the layer is on Alpha Lock. Then, change the lettering to the color black by tapping on the layer and selecting **Fill Layer** on the Layer menu.

6 Using the **Transform** tab, gently use your Apple Pencil to tap on the tablet screen to the right. Stop when you see the shadow effect take form.

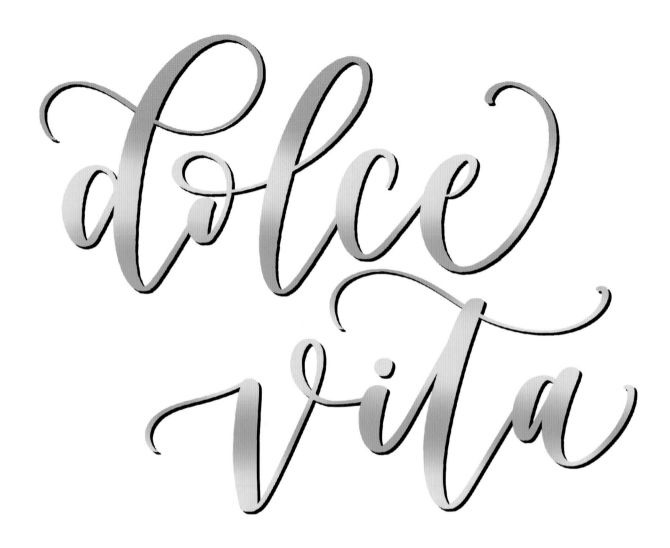

Yay, you're all set! I personally love doing this effect because it definitely makes the lettering artwork pop!

Dolce vita: **Sweet life (Italian).**

Using Gaussian Blur to Create Fun Backgrounds

This is also another favorite technique of mine because I love how the colors blend together when using the Gaussian Blur setting. The options and color choices are endless too! Any color can be used to create these fun backgrounds and this can be used for handmade cards, prints, and tags.

1 Open a new canvas, then open the Brush Library and select the **Hard Brush** in the Airbrushing folder. Take moment to look at the Color wheel and choose about three to five colors for this fun background. Increase the brush size to fit the canvas. My brush size is about 21% on an 8.5 × 11 inches (21.6 × 28 cm) canvas. When I create this piece, I love to start coloring the corners in circular shapes using my Apple Pencil and then coloring toward the center.

2 Choose another color and color the remaining corners. Add a third color between them.

3 Continue this process until the entire canvas is filled with color.

4 Open the **Adjustments** tab and select **Gaussian Blur**. Using your Apple Pencil, gently swipe to the right on the tablet screen to about 60% or to your preference.

This project is perfect for digital wallpapers and prints.

5 In the Layers tab, open a new layer by tapping on the **+** symbol at the upper right-hand corner. On the second layer, hand letter a word or phrase in any color; I chose the color white to add a nice contrast.

tip I create backgrounds and lettering pieces on separate layers just in case I mess up because once you exit out of the project and go back to the gallery, you cannot undo. I find that working on multiple layers works best for my artwork pieces.

Creating an Abstract Background Using the Wet Acrylic Brush

Procreate comes with so many fun brushes that can be used for anything! One of my favorites is the Wet Acrylic Brush from the Artistic folder. I love the texture this brush creates, almost a dry brush effect. This technique is a simple one, using the brush to create abstract backgrounds by drawing strokes and changing the color of the strokes.

Find the **Wet Acrylic** brush in the Artistic folder. Adjust the brush size to match the canvas and your preference. There's no right or wrong way to do this project. See the steps below to recreate my piece.

2 Next, draw a second line under the original horizontal line, but a little bit longer.

1 Draw a horizontal line in the upper left-hand corner.

3 Now, draw vertical lines in the bottom right-hand corner.

 I repeated the same process, but chose another color and overlapped the colors to show a mixture.

 Now, take a step back and identify the areas of negative space. Feel free to color these sections with another color by changing the pattern/direction of the strokes. For this example, I went ahead and overlapped the strokes by creating a **+** symbol and then a diagonal line in the middle. Be creative with it and draw a few strokes across the canvas. Remember to add a few more strokes if needed and change the color, theme, direction, and so on.

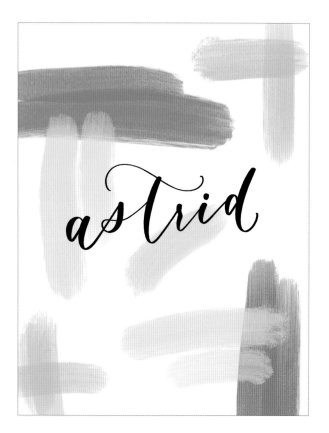

Optional: Open another layer if you would like to add some fun lettering. I wrote the name "Astrid" for this example using the simple lettering brush. This fun name print can be used for anything!

Outlining Lettering with a Galaxy Theme

This technique is all about taking a step back and creating something totally out of your comfort zone. I challenge you to take this time to pair your lettering with modern calligraphy and nonscript caps and to add fun flourishes (extending the entrance or exit strokes). Afterward, we will explore how to turn your lettering piece into a fun galaxy themed artwork by using techniques such as filling, recoloring, Alpha Lock, and using the other brushes from Procreate.

1 Hand letter anything you would like on layer 1 on a white background using your Apple Pencil. I challenge you to hand letter something totally different—just have fun with it! I used the simple lettering brush we created together in the last section (see page 53).

2 Open the Brush Library and select the **Calligraphy** folder. Choose the **Monoline** brush. On another layer, draw a bubble/outline around the lettering piece using the color black.

3 Using your Apple Pencil, tap the color wheel while dragging the color toward the center of the bubble. Make sure the outline of the lettering is all connected. If the outline is not completely closed, the entire layer will be filled instead of just the bubble.

4 The entire bubble should be only one color and completely filled.

5 Next, open the **Layers** tab; tap and then **Alpha Lock** the second layer (the same layer that has the outline/bubble around the lettering piece). You can also select the second layer and use two fingers to swipe to the right. Open the Brush Library again and choose the **Hard Brush** from the **Airbrushing** folder. On the second layer, draw a few strokes or lines across the bubble using a deep blue color.

6 Now using a deep pink color, repeat the same process by drawing a few strokes or lines.

7 Select the **Adjustments** tab and choose **Gaussian Blur**. Gently glide to the right on the tablet screen using the Apple Pencil, increasing the Gaussian Blur to about 50%.

8 Next, on a different layer, choose the color white and open the Brush Library again. Choose the brush called **Flicks** in the **Spraypaints** folder. Feel free to increase the Flicks brush and tap the screen very lightly. Continue the process and add a few more flicks. Make sure to tap lightly on the screen because this brush can easily fill the entire canvas. Our goal is to add a fun but simple effect.

9 Let's now move the first layer containing the hand lettering piece to the very top (on top of the third layer that contains the flicks) by using your Apple Pencil: Tap and hold down on Layer 1 until it becomes loose and you can move the layer around. Drag the layer to the very top of the Layers tab. You should now be able to see the lettering piece and the bubble behind the lettering text.

10 Let's now duplicate the hand lettering layer. Keep one of the layers in the color black and the other layer in the color white. Essentially, our goal is to have the lettering piece in the color white to make the artwork piece pop since the bubble background is a bit dark.

11 Let's use the other layer in the color black as the "shadow" for this piece. Select the **Transform** tab and using your Apple Pencil, gently tap on the tablet screen to the right until you see the shadow effect.

Awesome! You've created a fun, galaxy-themed lettering piece which can be used for anything—cards, prints, and gift tags!

Creating an All-over Pattern with a Simple Illustration

This project focuses on creating an all-over pattern background by creating a simple illustration and duplicating the illustration multiple times. Each time the illustration is duplicated, a separate layer will be created. The goal is to change the direction and/or resize each layer to create an all-over pattern.

1 Let's use the **Monoline** brush from the **Calligraphy** folder. We'll be drawing a simple leaf, starting with a curved line.

2 Start adding a few petals and continue the process.

3 Choose another color shade, select Alpha Lock, tap on the layer, and select **Fill Layer**. Then go back to the Layers tab and remove the Alpha Lock.

4 Start dragging the color, using your Apple Pencil to fill the petals.

5 Activate Alpha Lock the layer again and choose a yellow shade. Start drawing strokes into the petals for a fun contrast.

6 Opening up the **Adjustments** tab and increase the **Gaussian Blur** to about 25%.

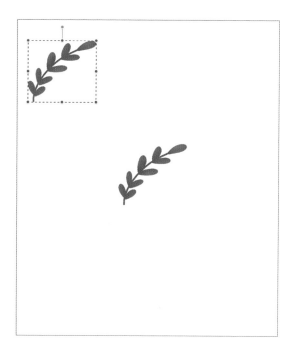

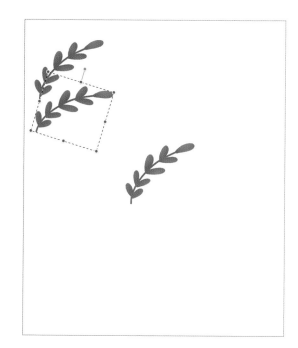

7 Let's now create a pattern effect by duplicating the leaf layer (duplicate it multiple times) to avoid recreating the leaf process each time, but using the original leaf drawn. Using the Transform tool, start moving the leaves across the canvas one at a time.

8 Continue the process by using the features on the bottom (Flip Horizontal, Flip Vertical, Rotate 45°, and so on).

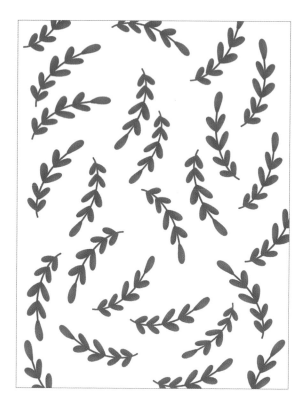

9 Continue to duplicate the layers, randomly pushing some leaves off the page. Remember to just have fun with it! Once you feel good about the pattern (it's okay if it's unorganized), you're all finished!

Enjoy this new artwork piece as a print, card, background, or however you'd like to use it.

Creating an All-over Pattern with a Geometric Shape

This project is similar to the previous all-over pattern technique (see page 86). We'll still be duplicating the original illustration and changing the direction. The goal this time is to make sure the illustrations are equally spaced out and symmetric. Let's have fun with this project!

1 Choose the **Monoline** brush from the **Calligraphy** folder to draw a triangle.

2 Now, tap and drag the Color wheel from the upper right-hand corner to fill the triangle using your Apple Pencil.

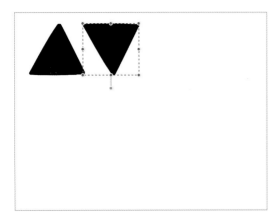

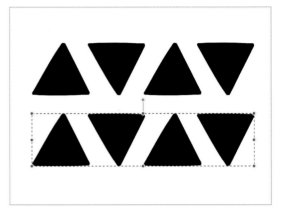

3 Let's now duplicate the layer to start creating a fun pattern by swiping to the left and selecting **Duplicate**. Using the **Transform** tab, click on the **Magnetics** at the bottom of the screen and move the triangle to the right (be mindful of the spacing).

4 Continue the process by duplicating the triangles to fit the row (horizontal direction) and moving the triangles around if needed. I duplicated the triangles four times to make them fit in the same line. For the second and fourth triangle, I changed the direction of them by selecting the **Transform** button and selecting **Flip Vertical** at the bottom.

- Now, open up the **Layers** and select all the layers by gently swiping to the right of each layer until they are all highlighted and then tap **Group** in the upper right-hand corner. The four triangles should all be in one group now.

- Select the arrow pointing downward on the new group layer next to the checkmark to merge the layers. Swipe the layer using two fingers to the left to duplicate. Now the four triangles have been grouped and duplicated.

- Use the **Transform** tab to move all four triangles around the canvas. Continue the process until the entire page is filled.

- I then selected all the layers by gently swiping to the right until all the layers are highlighted in order to move and center all the layers as one whole on the canvas.

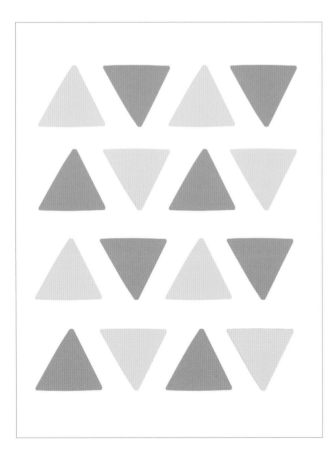

5 If you want to recolor, open each group individually, Alpha Lock the specific triangle, and then tap on **Fill Layer**. Continue the process by alternating the colors around. Remember to have fun with it! Once you're satisfied with the piece, you have now created a fun structured pattern!

This pattern is perfect for prints and as a lettering background.

Creating Swirl Backgrounds Using the Liquify Feature

The Procreate app comes with many neat features, and I love taking advantage of them. When I started experimenting with this feature, I loved the swirls and patterns that can be created. This project is all about exploring the Liquify Feature and choosing different color combinations.

1 Using the **Hard Brush** from the **Airbrushing** folder, fill the canvas with two different colors, creating a vertical pattern.

2 Open the **Adjustments** tab, and select **Liquify**. The menu at the bottom of the screen should appear: Leaving it on the **Push** effect, use your Apple Pencil to start drawing horizontal lines (in one direction left, then right, and so on) starting from the top and going down.

3 Feel free to explore different directions. I created this pattern by focusing on one area with an up and down motion and then a swirling one. Repeat this process all over the canvas by making bigger swirls. Once you're happy with the pattern, open a new layer to letter on.

4 Letter on a new layer using any color and then duplicate that layer to create a shadow effect.

5 Select the **Transform** tool and using your Apple Pencil, tap the screen to the right. Once you start seeing the shadow appear, feel free to adjust the shadow layer to your preference—the shadow layer can appear thin or thick.

This fun feature is perfect to create abstract artwork pieces and can be used for cards, posters, invitations, and so much more!

Danke: Thank you (German).

Using Your Lettering in a Photo

This technique reviews the process of lettering on a photo to create that 3-D illusion. I love using this technique because it's almost as if your photo comes to life paired with your lettering. We will explore the use of layers and ways to decrease the opacity to create this piece.

(A)

(B)

1 Create a new canvas on Procreate and import your favorite photo. The photo I'll be using for my example is from my visit to Piha Beach in New Zealand paired with the word "wow."
- Open a new layer and letter a word describing the photo using the simple lettering brush (see page 53) or any brush of your preference.
- Select the **Eraser** brush and choose **Medium Hard Airbrush** from the **Airbrushing** folder.

- Take a step back and identify the areas where the lettering could be incorporated into the photo. In my example, I notice that the lettering can appear behind the mountains and clouds **(A)**. Feel free to zoom into the photo to see the small details and start erasing your lettering to give the illusion that it's being incorporated into the photo **(B)**.

(C) (D)

2

There will be places where
you want to be exact and fol-
low the objects in the photo
(C). If you're having a hard
time, select **Adjustments**
and decrease the **Opacity**
(D) This will allow you to see
the photo and erase more
precisely. Repeat the process
and find ways to incorporate
the lettering into the photo.

Once you're finished, increase
the spacing then zoom out
and you should notice that
your lettering has been incor-
porated into the photo. I think
these letteirng pieces add a
fun element to your photos.

Adding a Dot Effect
to Your Lettering Pieces

This project reviews the simple effects that can be added to complement your lettering design. I love how the effect is simple, yet adds a finishing touch that will make your lettering designs pop.

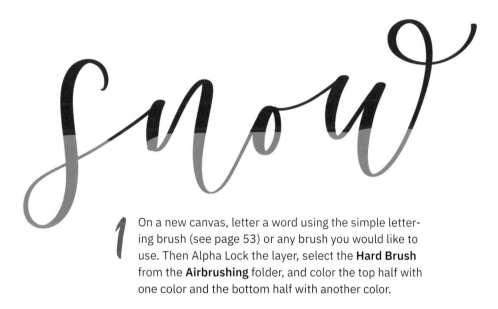

1 On a new canvas, letter a word using the simple lettering brush (see page 53) or any brush you would like to use. Then Alpha Lock the layer, select the **Hard Brush** from the **Airbrushing** folder, and color the top half with one color and the bottom half with another color.

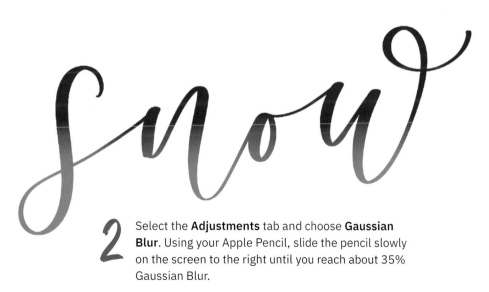

2 Select the **Adjustments** tab and choose **Gaussian Blur**. Using your Apple Pencil, slide the pencil slowly on the screen to the right until you reach about 35% Gaussian Blur.

3 From the Brush Library choose the **Monoline** brush from the **Calligraphy** folder and select another color. Zoom into the canvas to make it easier to see when drawing the dots. Add a new layer and using your Apple Pencil, start drawing a cluster of dots from the bottom of each letter going upward.

4 The higher the dots, the fewer dots there should be. Continue the process for every downstroke of each letter in the word.

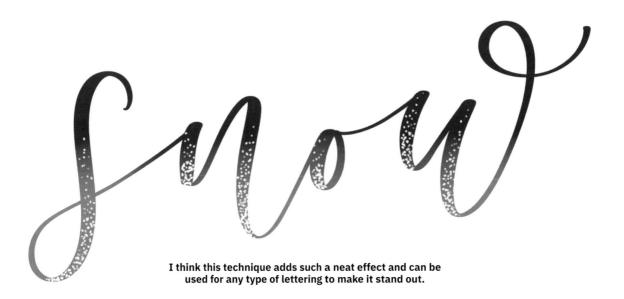

I think this technique adds such a neat effect and can be used for any type of lettering to make it stand out.

Combining Procreate & Adobe Sketch

I ABSOLUTELY LOVE USING THE ADOBE SKETCH app to create digital watercolor pieces. Not only is it fun to use, it's also very similar to real watercolors in the way the paint spreads in different directions, and if you don't work quickly, the "paint" will "dry," which is pretty neat! For the remaining techniques in this chapter, you'll need an iPad or iPad Pro, an Apple Pencil, Procreate app, and Adobe Sketch app. See also the projects on pages 103–131, which also incorporate Adobe Sketch.

Creating a Splash of Digital Watercolors & Text

This technique explores using the Adobe Sketch app and pairing the background designs with your lettering. I enjoy using this app because it creates such lovely watercolor designs and the final product is perfect to display in your office or home.

1

Open the Adobe Sketch app on your tablet and, in the lower right-hand corner, find the + symbol to open a new canvas.

- Select the 8.5 × 11 inches (21.6 x 28 cm) Letter (Portrait) for this technique example.
- Select the second-to-last brush (Water brush). This should open the Water brush folder where you can see the size, flow, and color of the brush.
- Using the Apple Pencil, start drawing a small circle in the center of the canvas, noticing that the watercolor will start to spread and expand.

2 Again using the Apple Pencil, start drawing the circle bigger and make sure to continue to press down. The more pressure that's applied, the more color will become present.

3 Continue this process a few more times (make sure to work fast) until the circle gets bigger and the paint starts to spread.

(A)

(B)

4 After a few seconds, you should notice the spreading paint gradually stopping, which means you can now save the artwork piece. A few things to note before saving:
- I always turn off the "background" layer by double tapping the Background box. This will then create a checkered background **(A)**.

- The only artwork piece we will be saving is the sketch layer. In the upper right-hand corner, select the icon that has a box and arrow pointing out, then select **Save Image** (B).

5 Let's now bring this watercolor piece into Procreate. Open an 8.5 × 11 inches (21.6 × 28 cm) canvas on Procreate and, in the Actions, select "Insert a photo." This should access your photo library, where you can then select the saved watercolor piece we just worked on in Adobe Sketch.

6 Feel free to adjust the position of the watercolor piece however you would like.

7 Another reason why I like to turn off the "background" layer in Adobe Sketch is because only the watercolor piece is saved and has a transparent background. This also means that you can recolor the watercolor piece with no problem! Open the layers, select another color, then select alpha lock and choose "Fill Layer."

8 Choose your preference in color and then open a new layer to letter on! Then, add a shadow layer. In the layers, select the lettering layer and swipe to the left and select **Duplicate**. Choosing a different color, recolor the layer to create the shadow. Then, select the **Transform** tool and using your Apple Pencil, lightly tap the screen to the right until you're happy with the shadow effect. Here are the finished pieces in two different colors!

Amico: **Friend (Italian).**

Experimenting with Digital Watercolors & Text

One of the great things about Adobe Sketch is the ability to create so many variations. Definitely take this time to explore, experiment, and have fun! For this example, let's create another fun watercolor wash.

1 Open a new canvas (8.5 × 11 incehes [21.6 x 28 cm]) on Adobe Sketch and select the **Water Brush**. Choose any color you like and gently draw continuous lines in a back and forth motion on the canvas (starting from the top and going downward at an angle). For the brush size, I kept mine at 300.

2 Using the same motion, add another layer and apply a little bit more pressure this time. Repeat the process until the wash is no longer transparent.

3 Now, double-tap the background box (this will hide the layer and create a checkered pattern). Then, select the button in the upper right-hand corner (box with an arrow pointing outward) and select **Save Image**.

 Next, open a new 8.5 × 11 inches (21.6 × 28 cm) canvas on Procreate to match the same canvas size from the watercolor piece created on Adobe Sketch. Select the Actions folder and then select **Insert a photo**.

Choose the watercolor piece we just created and feel free to angle, resize, or re-center if you like.

On a new layer, hand letter anything you like.

In this example, I decided to duplicate the lettering layer two more times to select and move the text around to fill the watercolor area. Your finished piece can be used for prints, cards, or anything you like!

Grazie: **Thank you (Italian).**

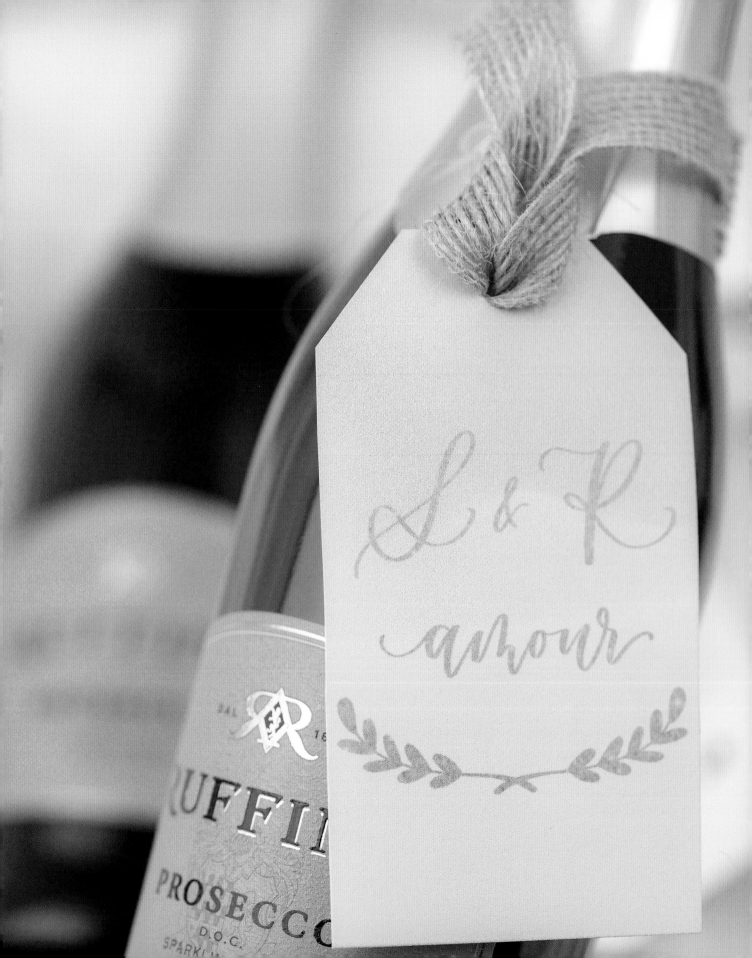

digital lettering projects

This chapter is all about creating projects, from lettering to using the iPad Pro to printing the artwork pieces. We're basically going to combine everything we've learned about lettering throughout this book, using the Procreate app, digitizing, and more! Although one version of the project may be demonstrated, always keep in mind that these projects can be incorporated and used for multiple purposes and occasions—all you need to do is change the wording, color theme, and so on to fit your needs. The techniques stay the same. Let's take it step by step, and have fun with it!

COLORFUL GEOMETRICS & LETTERING

THIS PROJECT IS ANOTHER FAVORITE OF MINE because we will be exploring ways to create straight lines and pairing the sections with different color blends. This project is simple but also a super fun technique because of the splash of color that will be added to your lettering!

1 Open a new canvas and select the **Monoline** brush from the **Calligraphy** folder. Using the Apple Pencil, start drawing a few lines across the canvas. Remember when you draw a rough line while holding the Apple Pencil down, Procreate will perfect and straighten out the line for you.

2 Continue this process, filling the entire canvas with lines going in different directions (the shapes should be all different sizes).

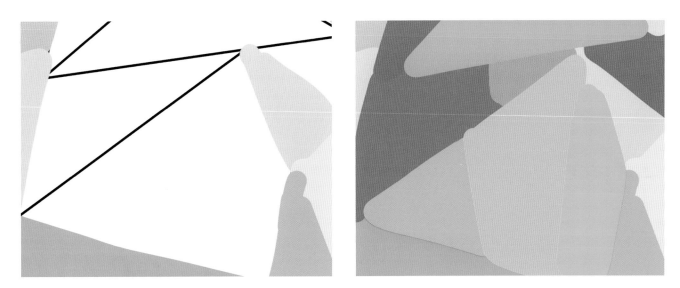

3 Select the **Hard Brush** from the **Airbrushing** folder. On a separate layer (lLayer 2), start filling the triangles by using Layer 1 as a guide. Have fun during this process by adding one or two different colors in one triangle. Fill and color the entire canvas.

4 Now, hold down Layer 2, dragging and placing the layer below Layer 1.

5 Select and tap Layer 1 and then select Alpha Lock. Select the color white, tap Layer 1 again, and then select **Fill Layer**.

6 Select layer 2, then select the **Adjustments** tab and **Gaussian Blur**. Using your Apple Pencil, swipe to the right on the screen and stop once you reach about 50%.

7 Open a new layer for your lettering and letter a positive quote using your Apple Pencil.

You're all done! This piece can be used as a card or print. Feel free to print it out and carry it with you for a positive reminder!

project 2

CUSTOM INVITATIONS

ONE OF THE MANY REASONS I LOVE USING THE PROCREATE APP is that it gives me the flexibility to create custom invitations, cards, and so much more! I love the process of creating a canvas size and working on multiple layers (lettering layer and illustration layer). The techniques this project covers can be used for other projects such as party cards and thank you cards.

1 Open a new canvas based on the invitation size you would like. I'm using a 5 x 7 inches (13 x 18 cm) canvas size. On Layer 1, draw a few outlines of balloons (we're creating a birthday theme for this example) using the **Monoline** brush. Use a different color for each balloon.

2 Then, using your Apple Pencil, drag the Color from the upper right-hand corner and fill the balloons.

3 If you want to add a fun touch, choose the color white and draw a curved line in the inside of each balloon close to the edge to create a shiny effect.

CUSTOM INVITATIONS

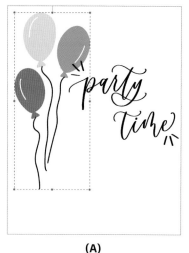

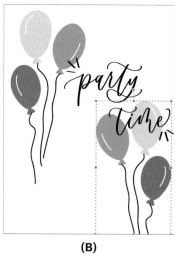

(A) **(B)**

Open **Layers** and select the **+** symbol to add a new layer.
- On Layer 2, hand-letter phrases such as "party time" or "birthday party." On Layer 3, I added three lines above the word "party" and below the word "time" as a further embellishment (A).
- Open **Layers** and select Layer 1 to duplicate the layer. Move the second set of balloons wherever you would like on the canvas. In this example, I decided to move them to the lower right-hand corner for symmetry (B).

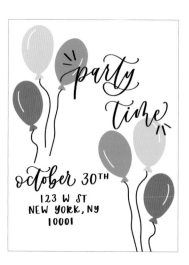

On a new layer, hand letter the date and address of the party. In this example, I decided to hand letter the party details in the lower left-hand corner.

Optional: Try duplicating the layer that has the text "party time." The goal is to create a shadow effect since the balloon is behind the text. Alpha Lock the duplicated/shadowed layer, choose the color white, and then select **Fill Layer**. Select the **Transform** tool and using your Apple Pencil, tap the screen to the right a few times until you see the white shadow appear.

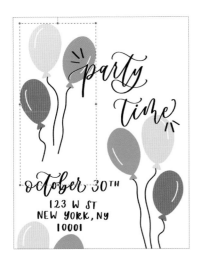

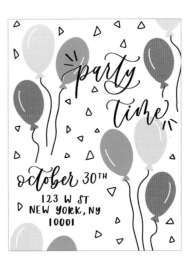

 Duplicate Layer 1 again to add a few more balloons to the lower left and upper right corners to fill the negative space. Select the **Transform** tool to select the duplicated layer with the balloons to move it freely around the canvas.

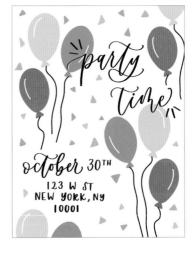

To add a finishing touch and fill the negative space, feel free to draw confetti or mini shapes all over the canvas.

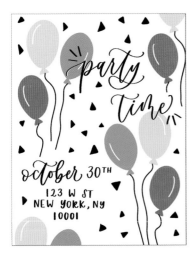

 Using your Apple Pencil, drag the color from the upper right-hand corner onto the canvas to color the shapes.

Next, open **Layers** and merge any layers together, if you like. I decided to merge all the balloons together. Select and tap the layer that has the confetti and turn on Alpha Lock. Then select the **Hard Brush** from the **Airbrushing** folder (decrease the brush size if you need to) and select different colors when recoloring.

Once you're happy with the overall layout and design, you can send this invitation
via email or text or print the invitation to mail to your family and friends.

CREATING CARDS WITH ADOBE SKETCH & PROCREATE

THIS PROJECT IS SIMILAR TO THE ADOBE SKETCH TECHNIQUES shown on pages 97-101, but the technique of creating the watercolor background is different. Here, we create the watercolor background starting at the top of the canvas, then import the watercolor design into Procreate to create printable cards.

1 Open a new canvas on Adobe Sketch and select the Water brush. Here, I'm using an 8.5 × 11 inches (21.6 × 28 cm) canvas size. Leave the brush size at 300 and choose any color you like. Using the Apple Pencil, draw a few continuous strokes at the top (about one third down from the top).

2 Repeat the same process, but apply a little bit more pressure to fill the top. Then, add one more layer, but remember to apply a little bit more pressure.

3 Now, on the left-hand side, select the **Flow** button and then swipe down. Using this opportunity to change the flow of the watercolor paint, gently run your Apple Pencil across the canvas where the paint is located and meets the paper. After a few seconds, you should now notice the paint is slowly moving in a different direction. Double-tap the background layer and save the image.

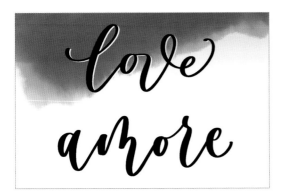

 Open a new 8.5 × 11 inches (21.6 × 28 cm) canvas in Procreate. Select **Actions** and insert the watercolor piece you just created in Adobe Sketch.

- Open the **Layers** and add a new layer to letter on.
- Feel free to duplicate the lettering layer to create a shadow effect. Choose another color, select the shadow layer and turn on Alpha Lock, then select **Fill Layer** to recolor. Select the **Transform** tool and tap on the screen to the right using the Apple Pencil to see the shadow effect appear.

 To create a card, open **Layers** and highlight or select all the layers. Select the **Transform** tool (located at the bottom) to rotate (45 degree, flip horizontal, etc.) and using two fingers, zoom in and stretch the layers together if you need.

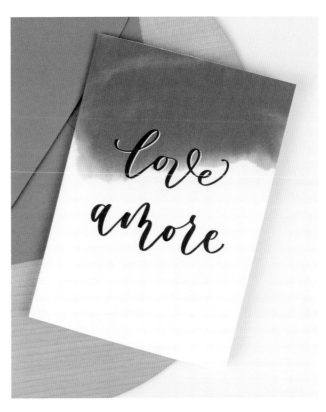

Our goal is to put the artwork piece on the right-hand side, leaving the left-hand side empty so that we can fold it in half to create a card.

After you're happy with the artwork piece, feel free to save the image and send it to your laptop (via AirDrop, USB cable, or email). Print it out, cut the edges, and fold the flap to create a card.

COLORFUL NAME TAGS

THIS PROJECT FOCUSES ON CREATING A WATERCOLOR BACKGROUND ON ADOBE SKETCH and then creating name tag templates on Procreate to print out for any occasion. Because I love this technique and the process of creating them, I create these name tags often for my workshops and family parties!

1 Using Adobe Sketch, open a new canvas and select the **Water brush**. I am using an 8.5 × 11 inches (21.6 × 28 cm) canvas size. Select any color and draw a few circles in the upper-left and bottom-right corners. Continue this process and increase and decrease the brush size for each color chosen.

2 The goal is to have a mixture of circles all over the canvas in different sizes.

3

Continue to fill the entire canvas with a variation of colors. Once you're happy with the artwork piece, double-tap the background and save the image.

4

Next, open a new canvas (same dimensions as in Adobe Sketch, 8.5 × 11 inches [21.6 × 28 cm]) on Procreate and select **Insert a photo** to import the watercolor piece you just created in Adobe Sketch.

- Open a new layer to create guidelines for the name tag and deselect the layer with the background piece for the layer to remain "hidden."
- Using the Monoline brush, draw a vertical line in the center of the canvas. Make sure to use the Transform tool to center and rotate if needed.
- Next, start drawing horizontal lines beginning about one third from the top.
- Continue to draw more lines until the boxes are all even.

tip If you draw a rough straight line and keep the Apple Pencil on the screen, the line will perfect itself and straighten out. The lines can also be drawn on individual layers, making it easier to move them around if needed.

COLORFUL NAME TAGS

5 Now turn the background layer (Inserted image) back on by checking the box.

6 Select the layer with the lines (Layer 1) by tapping and selecting **Alpha lock** and then fill the layer (recolor to the color white). Note: The recoloring process to the color white has made it easier for the printing/cutting process and saves you black ink.

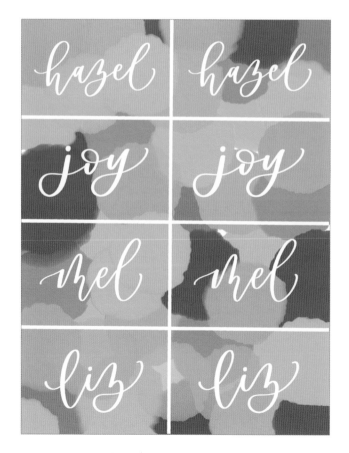

7 On a new layer, start lettering the names you'd like to use on the tags. In my example, I'll be making two name tags per person.

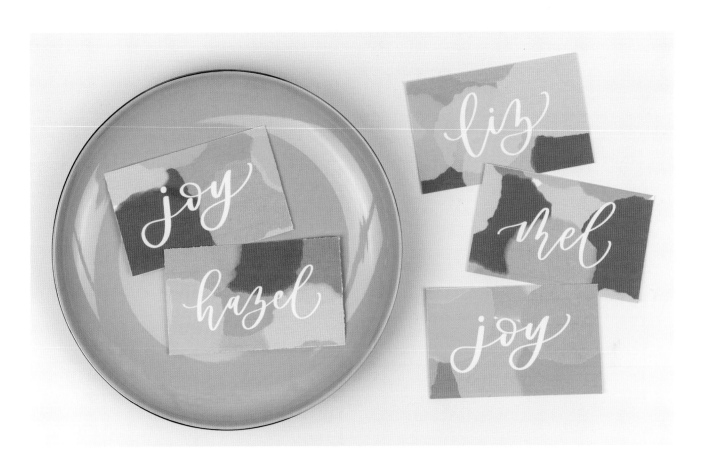

Once you're done lettering the names and are happy with the results, save the image and print and cut the name tags, using the grid lines to help you cut evenly. Perfect for any occasion, these name tags can use any color theme or pattern!

Here's another version of the name tags. The same template was used, but the background pattern is different. (See page 89 for the technique.)

LOVE TAGS

THIS PROJECT BASICALLY COMBINES EVERYTHING WE'VE ALREADY DONE ON ADOBE SKETCH (watercolor washes) and Procreate (shadow effects, gold foil illusion, and adding illustrations) to complete the tags. These personalized love tags are perfect for Valentine's Day, anniversaries, and weddings.

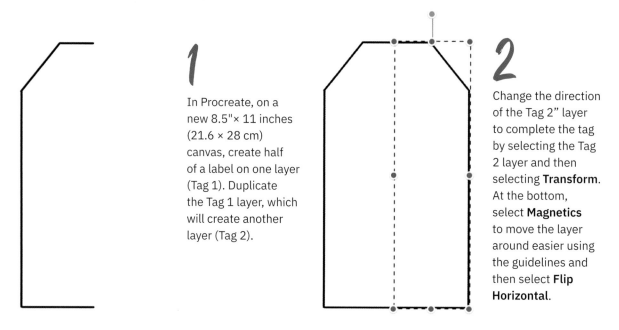

1 In Procreate, on a new 8.5"× 11 inches (21.6 × 28 cm) canvas, create half of a label on one layer (Tag 1). Duplicate the Tag 1 layer, which will create another layer (Tag 2).

2 Change the direction of the Tag 2" layer to complete the tag by selecting the Tag 2 layer and then selecting **Transform**. At the bottom, select **Magnetics** to move the layer around easier using the guidelines and then select **Flip Horizontal**.

3 Combine layers Tag 1 and Tag 2 by merging the layers together. Tap the Tag 2 layer and select **Merge Down**.

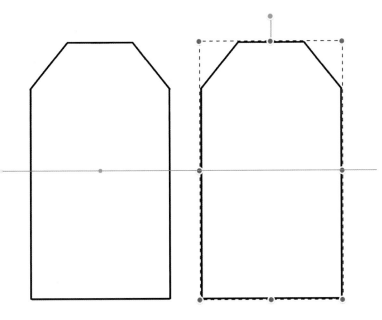

4

Let's now open up the layers to duplicate the tags twice by swiping to the left using one finger, or the Apple Pencil, followed by tapping **Duplicate** to create multiple tags on one page. Selecting one layer and then selecting the **Transform** button can move around the individual layers. This needs to be done for each layer individually with the tag. Note: Keeping the **Magnetics** button turned on at the bottom will allow you to move the tags in a straight line. The goal for this example is to have two rows of three tags total in a horizontal direction and then merge all the tags into 1 layer.

Duplicating more layers to create another row of tags.

project 5

LOVE TAGS

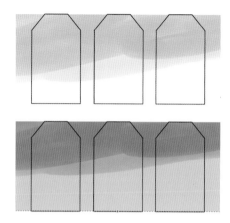

5 Next, import a wash image you've created previously on Adobe Sketch into the canvas. In this example, I used a watercolor wash where the wash isn't covering the entire tag, but a majority of it. Also, I imported two different images to have different colors for both the top and bottom sets of tags.
- Merge the Wash layers together (Wash 1 and Wash 2) by tapping the Wash 2 layer and selecting **Merge Down**.

6 Select the Wash layer and hold the layer down until you're able to move it. Then, place it below the Tag 1 layer.
- Adjust the Wash 1 layer in order for it to fit nicely as a background for the tags by using the **Selection** and **Transform** button and moving the layer around if needed.

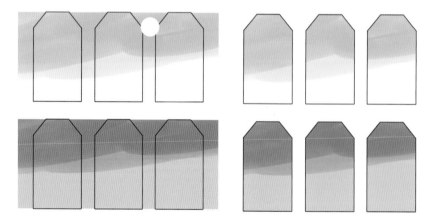

7 Now, select the Tag 1 layer and then drop in the color white onto the canvas to remove the excess background. **Note:** *The reason why the excess background for the tags is being removed is because we're recoloring the background with the color white. However, the inside of the tags won't get recolored because the tags are drawn with solid lines, which prevents the white recolor from being included inside the tags (unless the drop of color is placed inside a tag).*

8 Open a new layer to start creating fun
lettering pieces to complement the tags.
Optional: Duplicate the lettering layer and
change the color (pick a contrasting color) to
create a shadow effect. In my example, I decided
to pick the color white for the shadow effect and
also drew a leaf design to add a finishing touch.

9 Shake things up a little by lettering vertically in the
tag or using different techniques such as the gold
foil effect (see page 76) and then using Gaussian
Blur (page 79). I also added small black dots in the
tags as reference for punching a hole after printing.

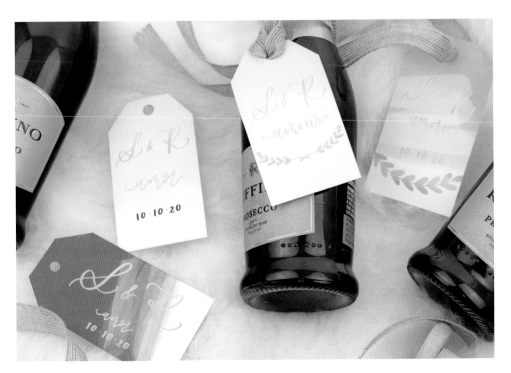

Awesome! Your
tags are ready to
print and will be
the finishing
touch for any
romantic occasion.

CREATING VINYL LETTERING WITH SILHOUETTE CAMEO

THIS PROJECT REVIEWS HOW TO USE THE SILHOUETTE CAMEO MACHINE to create your lettering into a vinyl. Vinyls are a fun way to personalize anything (mugs, dishes, and cups) and to basically create stickers of your lettering.

What You'll Need

- Silhouette Cameo machine
- Cutting mat for the vinyl
- Vinyl (I used Teckwrap Craft Vinyl)
- Transfer tape for the vinyl (I used Kassa's transfer tape)
- Vinyl weeding tool (picker)
- Vinyl squeegee
- Scissors
- Any item on which to apply the vinyl (journal, mug, etc.)
- iPad Pro, Apple Pencil, and Procreate app

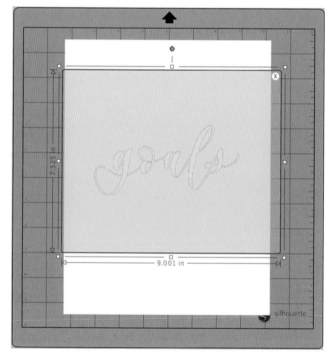

1 Hand letter a word or phrase using brush pens or the Procreate app.

2 Drag the lettering piece into Silhouette Studio and go to the **Trace** folder. Select the **Trace Area** and highlight the lettering, creating a box. Then deselct the **High Pass Filter**.

3 Then, select **Trace**. The lettering should be outlined in red now.

4 Let's now explore Silhouette Studio features. In the Offset folder, select **Offset**. For the distance, type **0.25** inches. This will create a fun bubble around the lettering.

5 Copy and paste the lettering only (without the bubble) and place it beneath the lettering with the bubble. Place the lettering pieces in the upper left-hand corner as you prepare to cut the vinyl. Open the **Cut Settings** folder, select **Standard** for the Cut Mode and **Cut Edge** for the Cut Style for Selected Shape. Then, choose the **Vinyl Silhouette brand** from the **Material Type** (Tool 1).

CREATING VINYL LETTERING WITH SILHOUETTE CAMEO

6 Scroll down on the right-hand side, and select the number **3** (Automatic Blade). For the speed Select type **1**, and for the thickness type **7**.

7 Cut a piece of vinyl large enough to cut your lettering design and apply it on the cutting mat. In this example, my vinyl piece was roughly about 3.5 × 3.5 inches (9 × 9 cm). Send your design to Silhouette for the cutting process.

8 After the Silhouette Cameo has completed the vinyl cut process of your lettering piece, remove the mat from the machine by unloading the mat from the Silhouette Cameo. Then, peel your vinyl off the mat.

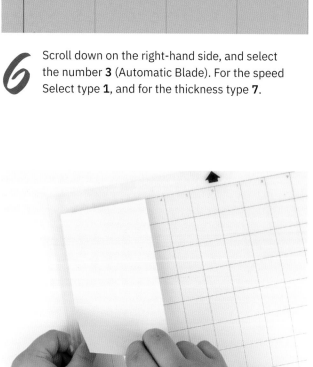

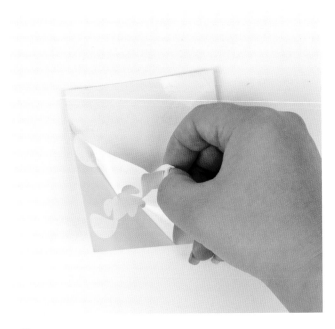

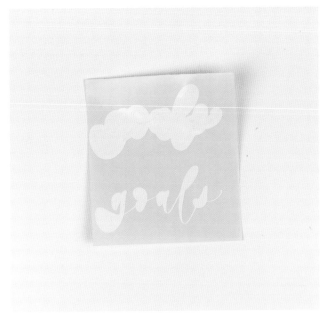

9 As you peel your vinyl, the cut areas will remain.

10 Using a vinyl picker, start removing the negative areas for the regular lettering (not the lettering with the bubble).

11 Next, for the lettering with the bubble, only remove the lettering part.

CREATING VINYL LETTERING WITH SILHOUETTE CAMEO

12 Cut around the lettering to work with one vinyl at a time.

13 When applying the vinyl, cut a small piece of transfer tape (large enough to cover the vinyl).

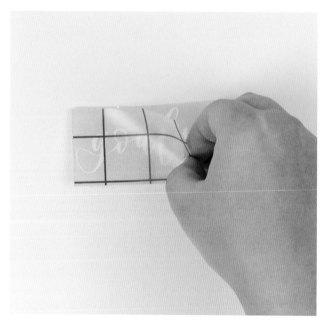

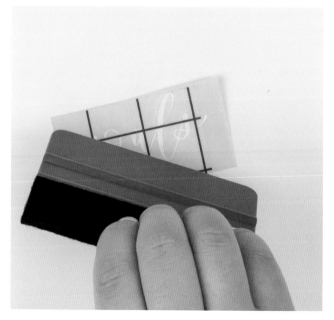

14 Peel the transfer tape and place it on top of the vinyl.

15 Using a flat edge, smooth out any bubbles and apply pressure so that the transfer tape sticks to the vinyl.

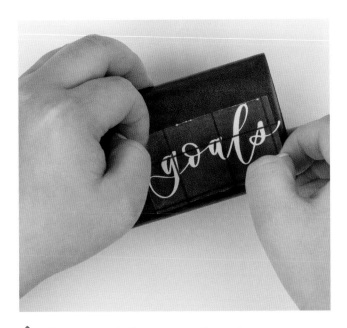

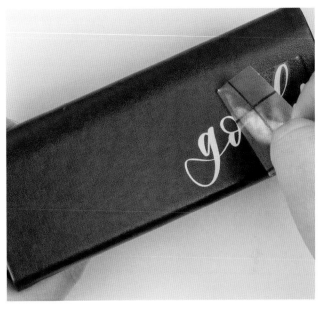

16 Next, apply the vinyl on a flat surface (I used a pencil case) and press down to smooth out any bubbles.

Get creative and personalize all your items!

APPLYING VINYL TO ACRYLIC PAINT

FOR THIS PROJECT, WE INCORPORATE ACRYLIC PAINT to create a nice contrast with the vinyl.

What You'll Need

- Paintbrush (I used Princeton Velvetouch Wash Brush)
- Acrylic paint (I used Master's Touch brand)
- Dish for the paint
- Acrylic plate (plate is from Uniqoo)
- Vinyl
- Transfer tape

1 Squeeze some acrylic paint into the dish and dip the paintbrush in the paint. Start painting horizontal strokes on the acrylic plate in a back and forth motion.

2 Continue this process by adding a few more layers of paint, letting each layer dry before adding another.

3 Wait for the paint to dry and then flip the acrylic plate to the other side (we'll be working on the smooth side). Next, apply some transfer tape on the vinyl and apply the vinyl to the acrylic plate.

4 Smooth out the vinyl to remove any air bubbles, and remove the transfer tape.

FOIL LETTERING WITH A LAMINATOR

IN THIS PROJECT, I SHOW HOW TO FOIL ONLY THE LETTERING while leaving the background without foil for an additional contrast. This process requires the creation of an artwork piece using your iPad Pro and Apple Pencil, then printing the lettering piece and background piece on the same sheet from separate printers. Following this, reactive foil will be placed over the lettering piece and both the artwork and foil will be placed through a heat source, such as a laminator, in order for the foil to react and adhere to the lettering piece.

What You'll Need

- Glossy Paper (I used Hammermill® Color Laser Gloss Paper)
- Reactive foil (I used Deco Foil from Therm O Web)
- Inkjet printer (optional if you do not want the background)
- Laserjet printer
- Laminator
- iPad Pro, Apple Pencil, and Procreate app

1 Using the Procreate app, hand letter your favorite word or phrase. I used the canvas size 8.5 × 11 inches (21.6 × 28 cm) in this example and lettered the phrase "dolce vita."

2 Select the **Monoline** brush and open a new layer. Outline around the lettering to create a bubble effect. Next, using the Apple Pencil, tap and drag the Color at the upper right-hand corner to fill the bubble.

3 Open the **Layers** and select **Alpha Lock**. Select the **Hard Brush** in the Airbrushing folder to recolor the bubble. If possible, color the bubble with alternating colors. I used two different colors here.

FOIL LETTERING WITH A LAMINATOR

4 Next, under **Adjustments**, select **Gaussian Blur**. Use your Apple Pencil to swipe to the right on the screen and increase Gaussian Blur to about 50%.

5 Open the **Layers** menu and hold the background layer (layer 2) until you're able to move it and place it below the lettering layer (layer 1).

6 Save the artwork pieces individually by deselecting the layers you're not saving and leaving the layer you would like to save selected. Save the background only as one image and then the lettering only as another image.

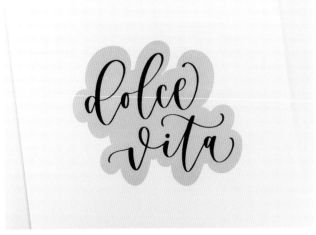

7 In order to make sure that the background is not foiled, print the background on an inkjet printer first.

8 Then to foil the lettering, print the lettering on a laserjet printer second. Only the laserjet toner will react to the foil.

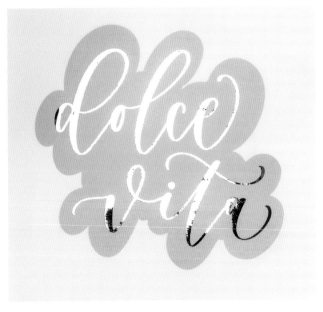

9 Next, cut a piece of foil large enough to cover the lettering. (**Optional:** Use a clear sheet to protect the paper and foil.) Turn on the laminator, and feed the paper and foil together through the laminator, positioning the foil on top of the lettering, covering the lettering. The laminator will heat up the laserjet ink where it will be tacky enough to allow the foil to react and adhere to the lettering only.

10 Now it's time for the exciting part—peel the foil off to reveal the foiled lettering! These foiled pieces can be used for gifts, cards, prints, and so much more.

Dolce vita: **Sweet life (Italian).**

inspiration gallery

Thank you again for joining me on this lettering journey. I hope you had an amazing time exploring the different lettering techniques and projects. I have poured everything I know about getting started in this book, and I am so happy to be sharing this process with you. On the following pages, I share some of my work and feature the beautiful work of two of my lovely #calligrabesties who I've met through the wonderful lettering community on Instagram and who completely blow me away with everything they create: Karin Newport of @ipadlettering and Myriam Frisano of @halfapx.

Karin Newport

KARIN OF @IPADLETTERING has long been my inspiration, and was the reason I wanted to start the beautiful process of iPad lettering. She was one of the first artists I found who created gorgeous lettering on the iPad Pro paired with the Apple Pencil. After following her work for a few years, I was completely inspired to start lettering on the iPad too.

Karin's work is completely one of a kind, and the way she incorporates various techniques in Procreate, such as watercolors and vibrant illustrations, is truly inspiring.

Karin Newport is a software developer, lettering artist, and graphic designer. She loves brush lettering and modern calligraphy, and has a special interest (bordering on obsession) in creating realistic-looking watercolor art digitally on her iPad Pro. She started her iPad lettering journey at the end of 2015 when she got her first iPad Pro and Apple Pencil. Since then, she's helped thousands of aspiring lettering artists by creating custom Procreate brushes, practice sheets, tutorials, and online courses.

Website: ipadlettering.com
Instagram, YouTube, Facebook, & Pinterest: @ipadlettering

Myriam Frisano

MYRIAM OF @HALFAPX inspires me with everything she creates. The amount of details, flourishes, and embellishments added in her artwork is truly beautiful. When I first found Myriam on Instagram, her stunning and elegant style inspired me to try traditional calligraphy and flourishing on both paper and on the iPad Pro.

Myriam's style is absolutely unique, with the way she incorporates different styles, details, and flourishes.

These photos showcase the designs Myriam created on the iPad Pro.

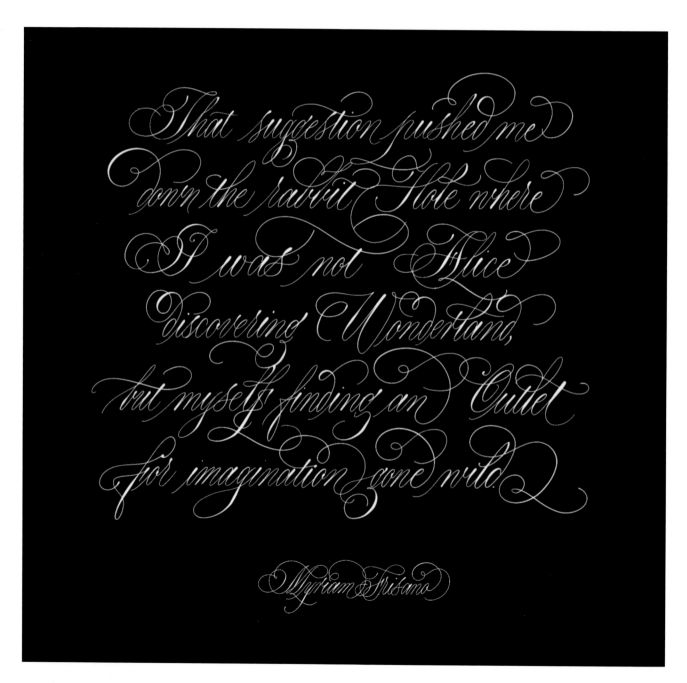

Myriam Frisano is a tech nerd. She works as a front-end engineer and does calligraphy as a side business. What may seem to be two totally clashing worlds—calligraphy and digital art—happily combine on the iPad Pro. Using the iPad opens up wonderful opportunities to make lettering shine, and the Undo button is also a great update.

Blog/Website: halfapx.com
Instagram, Facebook, & YouTube: @halfapx

Shelly Kim

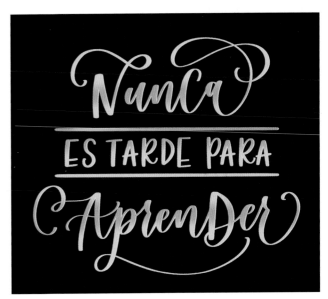

(Opposite, bottom left) *Isto també passará*: This too shall pass (Portuguese). (Opposite, bottom right) *Vivi, ridi, ama*: Live, laugh, love (Italian). (This page) *Nunca es tarde para aprender*: It's never too late to learn (Spanish).

drill sheet

The practice sheet below is for basic lettering drills: downstrokes, upstrokes, V-shapes, Mountain shapes, U-shapes (underturns), N-shapes (overturns), and Ovals (see page 19). Remove the sheet and trace the examples, or photocopy to create multiples. You can also find this practice sheet along with several others in both pdf and Procreate formats at https://www.quartoknows.com/page/digital-hand-lettering-and-modern-calligraphy

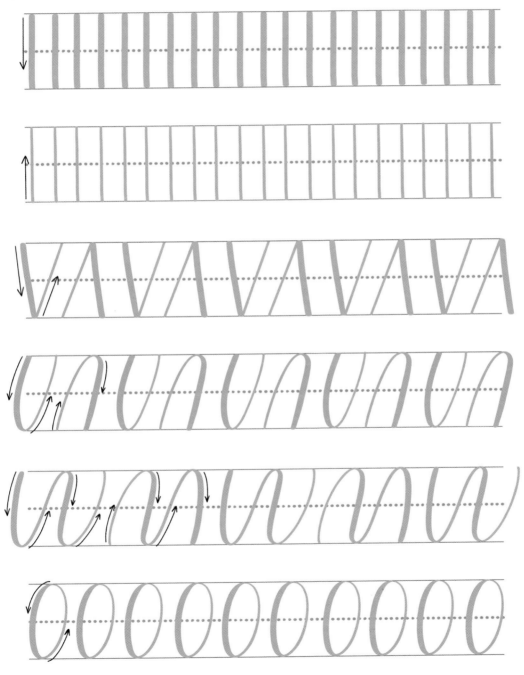

resources

ANALOG LETTERING ITEMS (PENS + PAPER):

- Tombow USA | www.tombowusa.com
- Royal Talens | www.royaltalens.com/
- Sakura of America | www.sakuraofamerica.com
- Crayola | www.crayola.com
- Pentel of America | www.pentel.com
- Marvy Uchida | www.uchida.com
- Hahnemühle | www.hahnemuehle.com
- Rhodia | www.rhodiapads.com
- HP Papers | www.hppaper.com/na/product/hp-premium-choice-laser-paper/

DIGITAL LETTERING ITEMS:

- Silhouette | www.silhouetteamerica.com
- Apple (iPad Pro + Apple Pencil) | www.apple.com
- Adobe | www.adobe.com
- Procreate | www.procreate.art

LETTERING RESOURCES/TUTORIALS (ONLINE):

- Karin | www.ipadlettering.com
- Myriam | www.halfapx.com
- Shelly | www.lettersbyshells.com

about the author

SHELLY KIM, creator of the popular Instagram lettering account @lettersbyshells, is a self-taught modern brush calligrapher who hosts in-person workshops throughout the U.S. on digital lettering, brush lettering, and watercolor lettering. She also offers entertaining and inspiring tutorials on YouTube and Facebook (both accounts: Letters By Shells) and is the author of two step-by-step technique card gift sets, *Learn to Create Modern Calligraphy Lettering* and *Learn to Create Art Deco Lettering* (both published by Rock Point). Shelly has also collaborated with a wide range of creative companies, including Apple, at their Today at Apple event, where she shared her artwork and story; Adobe Students, for their Spark Stories Sweepstakes; and with such crafts manufacturers as Tombow, Ranger Ink, and Prima Marketing. Shelly and her work have been featured on CBS News, Art Insider, and MOO.com. She lives in southern California.

acknowledgments

A huge thank you to the amazing Quarto team. Without your help, this book would not have been possible. Thank you for having so much patience with me and guiding me every step of the way.

THE EDITORIAL/DESIGN/ PRODUCTION/MARKETING TEAM:

LYDIA ANDERSON (marketing manager)—Thank you for always checking-in and sharing such great ideas!

JOY AQUILINO (acquisitions editor)—Thank you for your patience and believing in me! You have truly been there for me every step of the way. I will always cherish those long phone calls we had brainstorming and sharing ideas together.

JOHN GETTINGS AND RENAE HAINES (managing editors)—Thank you for helping me and walking me through the process.

MARISSA GIAMBRONE (art director)—Thank you for sharing and brainstorming with me. I had a wonderful time working together!

BARB STATES (production director)—Thank you so much for helping me with this process.

NYLE VIALET (editorial project manager)—Thank you for consulting and chatting with me and making me feel better whenever I was stressed out. You rock!

TO THE EXECUTIVE TEAM —Thank you so much for your help, your insights, and for your guidance.
Kristine Anderson (marketing director)
Ken Fund (chief operating officer)
Regina Grenier (creative director)
Mary Ann Hall (editorial director)
Winnie Prentiss (publisher)

TO KARIN AND MYRIAM—Thank you for being the best #calligrabesties and for your amazing friendships. Thank you for believing in my vision and allowing me to feature you and your beautiful artwork pieces in this book. Your guidance, support, and love have inspired me to accomplish so much with my own lettering journey. For that, I am forever grateful for you and our friendship! I am always here for you!

TO RICHARD, MY FOREVER LOVE—Thank you for always pushing me and believing in me. Your support, guidance, and love never goes unnoticed and I appreciate all that you have done for me. Thank you for always agreeing to every task I take on—Everyday is always an adventure with you and I am so glad it's with you!

TO THE LETTERING COMMUNITY—Thank you for following my lettering journey since 2015 when I had no idea what I was doing and just doing lettering as a hobby. A few years later, because of your love and support, I followed my dreams and pursued lettering full-time. It's been a crazy rollercoaster, but you have been there for me every step of the way. Because of your continuous love and support, I have been able to host lettering meet-ups, travel, and do workshops. Never in a million years did I ever think that it was possible and it's because of you. Always remember anything is possible and you matter—Focus on you and do what makes your soul happy!

TO MY #CALLIGRABESTIES—You definitely know who you are. Thank you for your guidance, support, and love you always give me. You have seen it all—my ups and downs and you understand every challenge and obstacle. Thank you for always uplifting and inspiring me. I appreciate and love you so much!

TO MY DAD, MY BROTHER, FAMILY, & FRIENDS—Thank you for your continuous love + support and for always cheering me on no matter what I do!

index

A

acrylic paint, 126–127
Adobe Illustrator, 44–45
Adobe Sketch
 cards project, 110–111
 love tags project,
 116–119
 name tags project,
 112–115
 Procreate and, 97–101,
 110–111
 watercolor splash,
 97–101
Apple Pencil
 color application, 58
 alternatives to, 50
 learning curve, 12
 practice strokes, 56
 pressure and, 50,
 53, 55
 Procreate and, 50
 round circles, 57
 straight lines, 57,
 104, 113
 thick strokes, 56
 thin strokes, 56
ascender line, 22

B

backgrounds
 gaussian blur, 79–80
 geometric shape back-
 grounds, 89–90
 illustration back-
 grounds, 86–88
 swirl backgrounds,
 91–92
 Wet Acrylic Brush,
 81–82
baseline, 22
bouncy lettering, 26–28
brush pens
 Crayola Broad Line
 Marker, 14

gripping, 16
holding, 16
large-sized lettering, 14
Marvy Uchida LePen
 Flex, 14
Pentel Fude Touch Sign
 Pen, 14
positioning, 16
pressure, 16, 17
Royal Talens Ecoline
 Brush Pen, 14
Sakura Koi Coloring
 Brush Pen, 14
selecting, 14
small-sized lettering, 14
Tombow Dual Brush
 Pen, 14
Tombow Fudenosuke
 Brush Pen, 14

C

cameras, 43
cards project, 110–111
connected letters, 24–25
color application, 58
Crayola Broad Line
 Marker, 14
Cricut Design Space, 46

D

descender line, 22
digital cameras, 43
digitizing
 Adobe Illustrator,
 44–45
 Cricut Design Space, 46
 digital cameras, 43
 digital files, 44–47
 flatbed scanners, 41
 introduction, 40
 letter capturing, 41–43
 Silhouette Studio,
 46–47
 smartphones, 42–43

dot effect, 95–96
double letters, 30
downstrokes, 18, 19, 20
drills. *See also* projects.
 bouncy lettering, 26–28
 downstrokes, 19, 20
 mountain shape, 19
 N-shape, 19
 O-shape, 19
 upstrokes, 19, 20
 U-shape, 19
 V-shape, 19

E

embellishments, 34, 36

F

Frisano, Myriam, 134–135
FiftyThree Digital Stylus, 50
flourishes, 31–33, 36
foil lettering project,
 128–131

G

gaussian blur, 79–80
geometrics project,
 104–106
glitter
 on black background,
 74–75
 on white background,
 72–73
"gold foil" effect, 76–78
guidelines, 22

H

Hahnemühle Hand Letter-
 ing Paper, 14
Hammermill® Premium
 Color Copy Cover
 Paper, 14
HP Premium Choice Laser-
 Jet Printer Paper, 14

I

inspiration gallery
 Karin Newport, 132–
 133
 Myriam Fasano,
 134–135
 Shelly Kim, 136–137
invitations project,
 107–109
iPad, 12, 50, 66–67

K

Kim, Shelly, 136–137

L

laminators, 128–131
loose-style lettering, 29
love tags project, 116–119

M

Marvy Uchida LePen
 Flex, 14
mountain shapes, 19

N

name tags project,
 112–115
Newport, Karin, 132–133
nonscript capital letters, 35
N-shapes (overturn), 19, 21

O

O-shapes (oval), 19, 21
outlined lettering, 83–85

P

paper
- angling, 17
- Hahnemüle Hand Lettering Paper, 14
- Hammermill® Premium Color Copy Cover Paper, 14
- HP Premium Choice LaserJet Printer Paper, 14
- Rhodia Paper, 14
- selecting, 14
- Strathmore® 400 Series Mixed Media Paper, 14

Pentel Fude Touch Sign Pen, 14

photo lettering, 93–94

pressure
- adjusting, 17, 18
- Apple Pencil and, 50, 53, 55
- downstrokes, 18
- pen position and, 16
- stylus options and, 50
- thick strokes, 18
- thin strokes, 18
- upstrokes, 19

Procreate
- Adobe Sketch and, 97–101, 110–111, 112–115
- alpha lock, 61
- brush creation, 53–55
- brush testing, 56
- cards project, 110–111
- circles, 57
- color fills, 58, 61
- color selection, 59, 61
- custom invitations project, 107–109
- dot effect, 95–96
- functions, 52
- galaxy theme, 83–85

Gaussian Blur setting, 79–80

geometric shape backgrounds, 89–90

geometrics project, 104–106

glitter images, 72–75

gold foil effect, 76–78

illustration backgrounds, 86–88

introduction, 51

layer duplication, 62

layer functions, 60

layer movement, 63

lines, 57

Liquify feature, 91–92

love tags project, 116–119

Magnetics tab, 65

name tags project, 112–115

new canvas, 51

opening, 51

outlined lettering, 83–85

photo lettering, 93–94

practice strokes, 56

Selection tool, 64

shadow effects, 69–71

stamp creation, 66–68

swirl backgrounds, 91–92

Transform tool, 64–65

watercolor and text, 97–99, 100–101

Wet Acrylic Brush, 81–82

projects. *See also* drills.
- cards, 110–111
- foil lettering, 128–131
- geometrics, 104–106
- invitations, 107–109
- love tags, 116–119
- name tags, 112–115
- vinyl lettering, 120–125
- vinyl on acrylic paint, 126–127

Q

quote designs, 36–37

R

Rhodia Paper, 14

round circles, 57

Royal Talens Ecoline Brush Pen, 14

S

Sakura Koi Coloring Brush Pen, 14

scanners, 41

Silhouette Cameo machines
- Silhouette Studio files and, 47
- vinyl lettering, 120–125

Silhouette Studio, 46–47

smartphones, 42–43

straight lines, 57, 104, 113

Strathmore® 400 Series Mixed Media Paper, 14

style development, 22

T

thick strokes, 18, 56

thin strokes, 18, 56

Tombow Dual Brush Pen, 14

Tombow Fudenosuke Brush Pen, 14

tools
- Crayola Broad Line Marker, 14
- Hahnemüle Hand Lettering Paper, 14
- Hammermill® Premium Color Copy Cover Paper, 14
- HP Premium Choice LaserJet Printer Paper, 14
- Marvy Uchida LePen Flex, 14
- Pentel Fude Touch Sign Pen, 14
- Rhodia Paper, 14
- Royal Talens Ecoline Brush Pen, 14
- Sakura Koi Coloring Brush Pen, 14
- Strathmore® 400 Series Mixed Media Paper, 14
- Tombow Dual Brush Pen, 14
- Tombow Fudenosuke Brush Pen, 14

U

upstrokes, 18, 19, 20

U-shapes (underturn), 19

V

vinyl
- applying to acrylic paint, 126–127
- lettering project, 120–125

V-shapes, 19

W

Wacom Bamboo Stylus, 50

Wacom Bamboo tablet, 50

waistline, 22